DRAW & PAINT
FANTASY ART

Warriors & Heroes

DRAW & PAINT
FANTASY ART

Warriors & Heroes

Alan Lathwell

IMPACT

To El and Del for being the best, and Siobhan, my
real life superhero.

A DAVID & CHARLES BOOK
Copyright © David & Charles Limited 2010

David & Charles is an imprint
of F&W Media International, Ltd
Brunel House, Forde Close,
Newton Abbot, TQ12 4PU, UK

F&W Media International, Ltd
is a subsidiary of F+W Media, Inc.
10151 Carver Road, Suite #200,
Blue Ash, OH 45242, USA

First published in 2010
Reprinted in 2012, 2015

A catalogue record for this book is available from
the British Library.

ISBN-13: 978-1-60061-969-4 - paperback
ISBN-10: 1-60061-969-X paperback

Printed in the USA by RR Donnelley
for David & Charles
Brunel House, Newton Abbot, Devon

Publisher: Stephen Bateman
Senior Commissioning Editor: Freya Dangerfield
Project Editor: Emily Pitcher
Editor: Verity Muir
Design Manager: Sarah Clark
Designer: Marieclare Mayne
Production Controller: Kelly Smith

David & Charles publish high quality books on a
wide range of subjects.
For more great book ideas visit:
www.fwmedia.co.uk

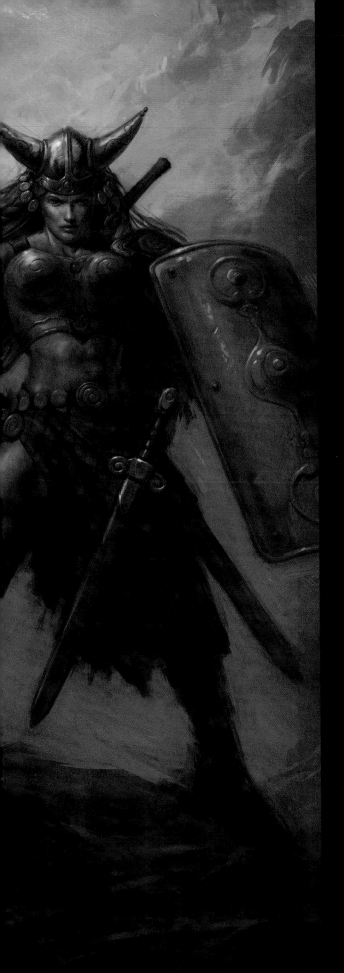

Contents

Introduction

Out of the darkness of history, the echoes of our ancestors shout the names of legendary heroes and warriors, whose feats and exploits defied the limits of man's strength and courage. Whether proving themselves on the battlefield or pursuing perilous quests, these champions dared to go to the extremes of human endurance, and emerged triumphant. The tales of these legendary figures have been preserved and handed down through the ages. From the ancient Epic of Gilgamesh to the medieval tales of King Arthur and his knights, the great storytelling tradition means that we have a wealth of material, both historical and mythological, from which to draw inspiration. Tales of struggle and triumph over great adversity seem to have struck a cord with our early ancestors and just as they were inspired to record these heroic tales for posterity, we are inspired when we read and hear about them today.

It was reading these ancient myths and legends as a child that inspired me to pick up a pencil and try to recreate those warriors and heroes. It was a natural outlet for expressing my awe and admiration for these larger than life characters, and a dogged determination to do them justice kept me practising until they began to resemble the images in my head. I devoured books on weapons and history to add detail to my pictures, and as I searched for other visual reference I discovered the work of the Pre-Raphaelites and Neo-Classical painters of the nineteenth

and rich colours of these paintings showed me what was possible with oil paint, and I was determined to teach myself the techniques so I could create my own epic paintings. A further development was the discovery of fantasy artists such as Frank Frazetta, whose dark depictions of warriors from distant times and fantastic worlds were obviously influenced by historical fact and mythological traditions, but were distorted and exaggerated in a way that felt dangerous and contemporary. It encouraged me to experiment with my own ideas, to create

My aim in writing this book is to bring to life some of the most exciting warriors and heroes from history, mythology and fiction and hopefully to inspire you to do the same! While I've set each warrior in the correct context, dressed and armed with regalia from their historical period, I've not aimed for historical accuracy – I've allowed the occasional flourish for added drama and used artistic licence when I felt the need. Giving your imagination licence to run free is what creating art is all about, and while a good knowledge of historical detail is beneficial, it shouldn't constrain you, – in fact it should act as a springboard for creating your own ideas.

The images in the book were created digitally but the instructions and advice also translate to traditional painting methods and materials. I have arranged the images in order of difficulty, starting with basic poses and working up to more dynamic figures using foreshortening and perspective to add drama and movement. Each tutorial introduces a new element to consider, such as dressing the warrior in complex armour, and as you rise through the ranks from recruit to veteran you will become equipped to create your very own warriors and heroes. So, armed with your pencil and eraser, let battle commence!

Materials

There is a wide variety of media available to the artist, ranging from traditional oil paints to digital software, each with its own unique qualities. Here's a list of some of the tools and materials available with a brief description of their qualities. Experimentation is the best way to find which medium suits your natural style, and the medium you choose will largely influence how your images will look. I recommend you try as many as possible.

PENCILS

Pencils offer a great way of capturing your ideas and getting them down on paper fast. They are versatile, immediate and responsive, offering a wide range of tones. Pencils are graded from 9H the hardest and lightest, to 9B the softest and darkest, with HB in the middle. Finding the right grade is down to personal style, but I recommend using an HB for lighter lines and initial sketching, and a 2B for stronger lines and shading.

HB Pencil for initial outlines

2B Pencil for darker lines and shading

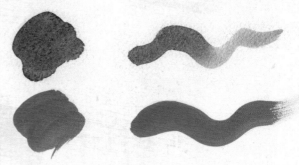

WATERCOLOUR AND GOUACHE

Watercolour is a transparent medium that is generally applied with subtle washes of colour using soft brushes. The effects should be fluid, spontaneous and fresh, allowing the white of the paper to shine through the colours, creating a luminosity unique to the medium. Overworking the colour can spoil its effects and watercolour is not suitable for opaque painting – gouache would be a much better choice for this. Gouache is an opaque watercolour capable of stronger colours; it can be modelled and over painted, and can be watered down to work in a similar way to watercolour.

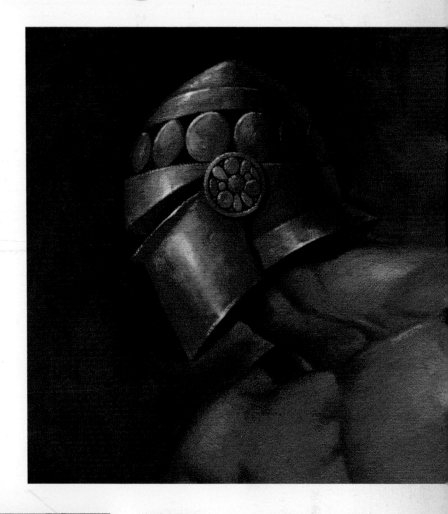

ACRYLICS

Acrylics are a fast-drying, flexible medium that can be applied using the same techniques as watercolour, gouache and oils. The rapid drying rate allows for the build up of thick textures and heavy impasto, and they can also be diluted with water and used as thin washes. The drying speed can be a bonus or a disadvantage depending on your painting style and care must be taken to keep your brushes moist while working to prevent the paint drying on the bristles.

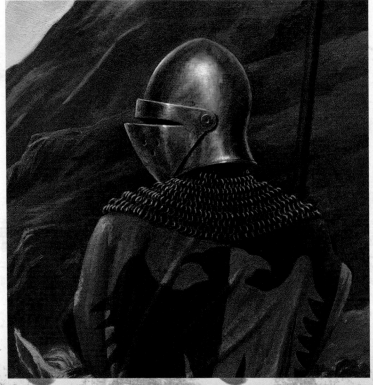

OILS

The rich tactile qualities of oil paint have made it a popular choice amongst artists for centuries. Oils are extremely versatile and can be used as thick impasto or thinned with solvents and applied as glazes. They have a very long drying time, anywhere between a day to two weeks depending on the thickness, which allows for subtle blending and manipulation of the paint. Careful planning is necessary when building layers, because the slow drying time can result in an unstable paint film if the lower layers are not fully dry before glazing on top.

DIGITAL

Creating art on a computer is becoming very popular, and there are many software packages available that replicate traditional painting media. The addition of a graphics tablet (a digital pad that you draw on using a stylus) further enhances the feel of drawing and painting traditionally. The sheer speed of execution makes it an exciting way to create art, and there is a wide range of effects available, from filters to overlaying textures. There is also the convenience of being able to correct mistakes at the press of a button, which allows plenty of scope for experimentation. Apart from lacking the tactile qualities of real paint, the only downside is that there is no physical artwork at the end, as it only exists on the computer or as a print.

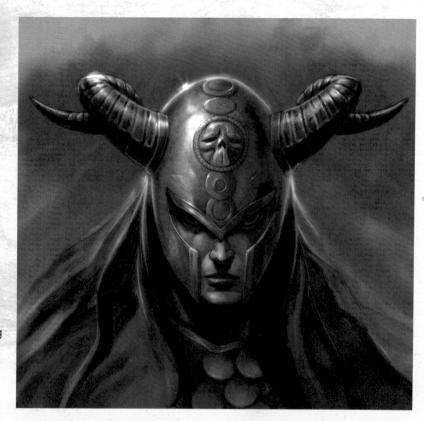

SUPPORTS

A support is the term given to the surface the artist works on, such as paper or canvas, and there is a wide choice available. The medium you decide to work in and the effects you want to achieve will largely determine the type of support you choose. It's worth mentioning that the application of wet media requires a thicker surface to prevent buckling, and using a primer such as acrylic gesso can make most surfaces suitable for acrylic and oil painting.

Cartridge paper is a good general-purpose paper with a smooth surface, and is ideal for pencil drawing and sketching.

Illustration board, sometimes called Bristol board, is also smooth and is good for line drawing and pen-and-ink work.

Watercolour paper is an ideal surface for pencil, gouache and acrylics as well as watercolour, and is available in varying weights and textures. The rougher textures provide lots of scope for dry brush and scumbling techniques, while the smoother papers are good for soft blending and smooth gradation of colours.

Canvas is the traditional surface for oils and acrylics, but boards such as hardboard and plywood can also be used as long as they are primed beforehand.

BRUSHES

Just like the medium and surface you work with, the brushes you use to apply the paint will also have an influence on the look of the final image. Softer brushes are good for subtle blending while stiffer bristle brushes provide texture and lively brushwork. Again, the brushes you use will be a personal choice but here is a basic range that I recommend for painting the warriors and heroes in this book.

TRADITIONAL BRUSHES

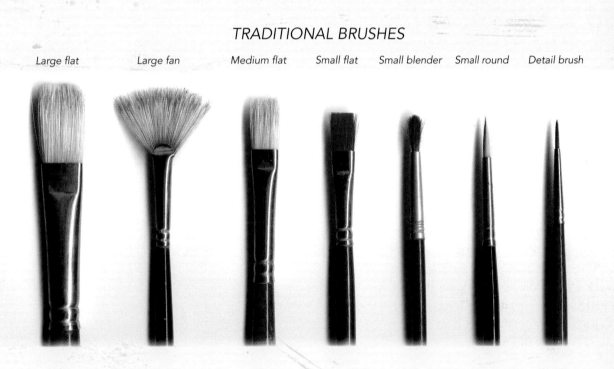

Large flat Large fan Medium flat Small flat Small blender Small round Detail brush

The larger flat brushes are good for blocking in the backgrounds, using the large fan brush to soften and blend the brushwork. The smaller brushes are for painting and detailing the figures, and ideally you should have a couple of each size, one for the darks and one for the lighter colours.

The digital artist has a much wider choice available to them, but here is a simple range of basic brushes I recommend for the tutorials (right).

DIGITAL BRUSHES

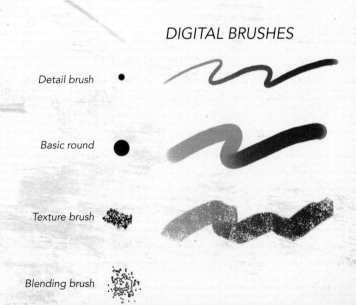

Detail brush

Basic round

Texture brush

Blending brush

Drawing the Figure

BASIC SHAPES

Before attempting to take on warriors and heroes it's important to arm yourself with some of the fundamental skills you will need to succeed. Most of the things we see, and that includes the human figure, can be broken down into simple geometric shapes such as spheres, cylinders and cubes.

The beginner should practise drawing these shapes from every angle, not only from imagination but drawing them from life. I recommend setting up a still life consisting of objects of various shapes, drawing and shading them under different lighting conditions to really gain an understanding of their forms.

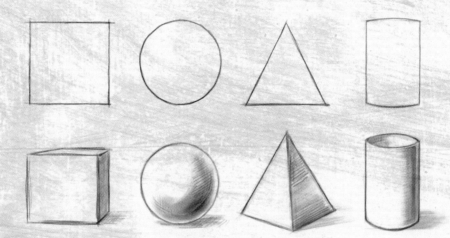

FORESHORTENING

Foreshortening is the effect perspective has on objects as they tilt towards the viewer – they appear to shorten in length and the parts nearer the viewer are seen as much larger than those in the distance. A thorough understanding of foreshortening is crucial to creating three-dimensional depth on a two-dimensional sheet of paper.

These illustrations show how a simple cylinder changes its shape as it turns towards the viewer. The length is vastly reduced and the end of the cylinder closest to the viewer increases in size, as it swings round. Also notice how the elliptical shape of the opening in the first view becomes a full circle in the third.

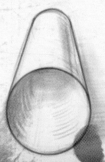

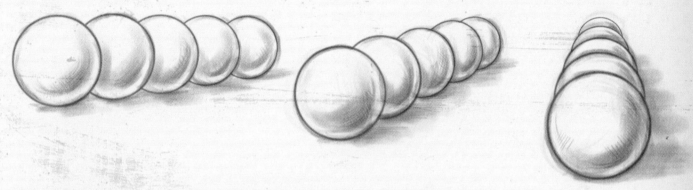

Another important thing to consider with foreshortening is the overlapping of forms. This illustration of a series of spheres in a row shows how the shapes in the foreground overlap those in the distance. This is important when you come to draw the figure, for example, imagine an arm reaching out towards you, consider how the muscles on the forearm would overlap and obscure those of the upper arm.

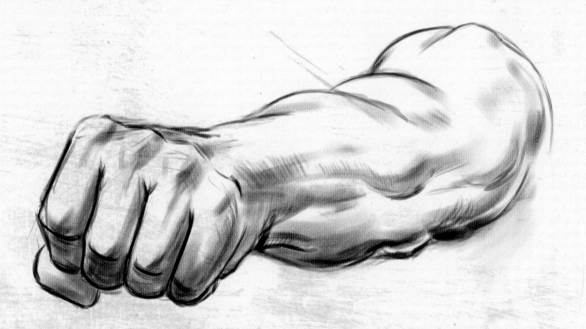

Once you have grasped these fundamentals you can move to tackling the figure!

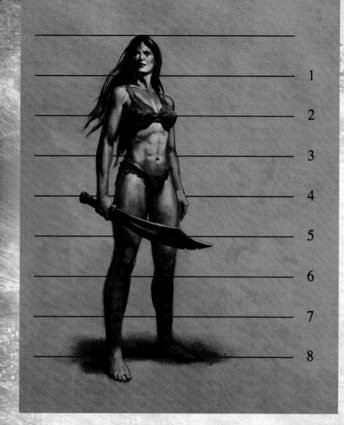

PROPORTION GUIDE

There are no strict rules for anatomical proportions but there are general guidelines that will help keep your figures looking realistic. Using the length of the head as a measurement, you can place the main landmarks of the body and determine the overall height of the figure. The average person is approximately seven heads tall, but in this book we are creating heroes, so using a guide of eight heads will make your figures taller and more imposing. This guide is the same for male and female figures although a woman's head is slightly smaller, which will make her a little shorter by comparison.

Familiarize yourself with the guide and use this checklist to ensure all parts of the figure are in proportion.

Checklist: Anatomy Proportion

Base of the pectorals land just over 2 heads down

Elbows and navel land just over 3 heads down

Base of pelvis 4 heads down

Hands land mid-thigh at 4½ heads down

Top of knees land 5½ heads down

Ankles land 7½ heads down

Figure is eight heads tall

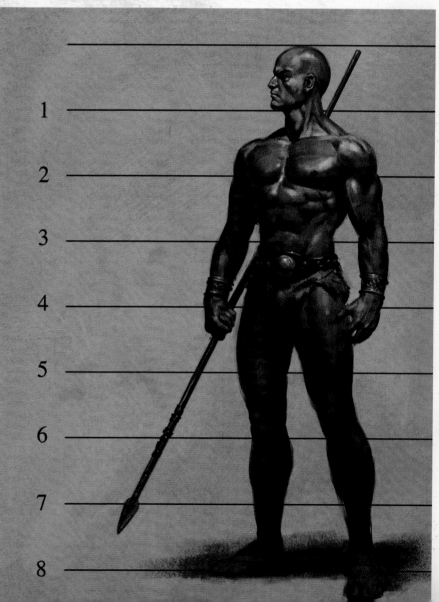

Warriors and Heroes

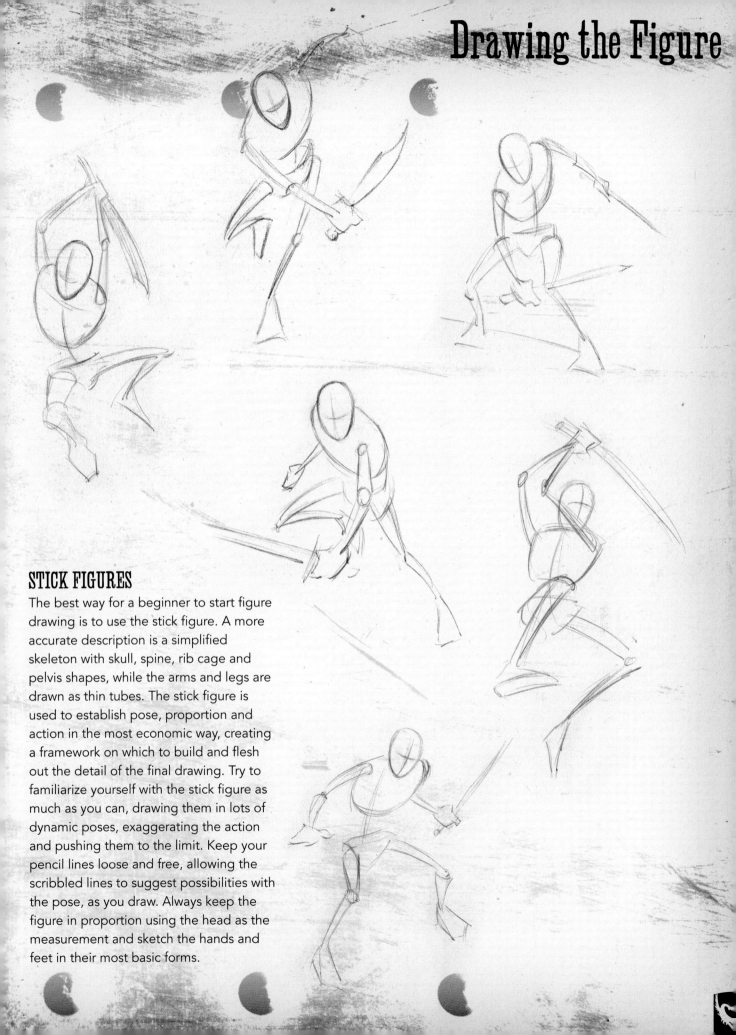

STICK FIGURES

The best way for a beginner to start figure drawing is to use the stick figure. A more accurate description is a simplified skeleton with skull, spine, rib cage and pelvis shapes, while the arms and legs are drawn as thin tubes. The stick figure is used to establish pose, proportion and action in the most economic way, creating a framework on which to build and flesh out the detail of the final drawing. Try to familiarize yourself with the stick figure as much as you can, drawing them in lots of dynamic poses, exaggerating the action and pushing them to the limit. Keep your pencil lines loose and free, allowing the scribbled lines to suggest possibilities with the pose, as you draw. Always keep the figure in proportion using the head as the measurement and sketch the hands and feet in their most basic forms.

DRAWING THE FACE

Once you have decided on a pose for the figure you can start adding the detail. Drawing the face can be simplified by using a few basic rules. Every face has its own unique character so these are just general guidelines for building a standard face. This system applies to both male and female faces.

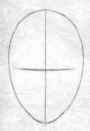

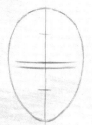

STEP 1

Draw the oval egg shape of the head, then draw a vertical line midway to indicate the centre of the face. Now draw a horizontal line midway between the top and bottom of the head, this is the eye line.

STEP 2

Just above the eye line draw another to indicate the brow. Next, draw a small line halfway between the brow and the chin to find where the bottom of the nose will fall, and another between the brow and the top of the head for the hairline.

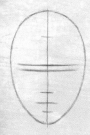

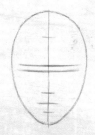

STEP 3

Place two lines equally apart between the nose and chin. The mouth falls on the upper line.

STEP 4

Now you have your structure you can draw the features on top. Use the checklist to help you place the features correctly -

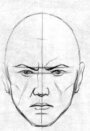

Checklist: Facial Features

The head is five eyes wide
There is one eye distance between the eyes
The nose is one eye's width
The tops of the ears are on the brow line, bottom of the earlobes are in line with the base of the nose

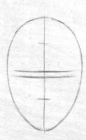

Warriors and Heroes

16

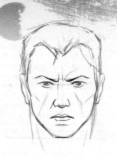
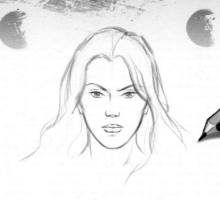

STEP 5
Finish by drawing the hair and erasing the construction lines.

The following drawings show how the centre line, eye line and placement of the ears indicate the position and direction of the head.

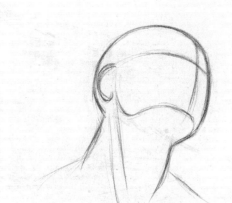
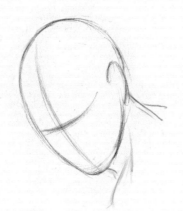
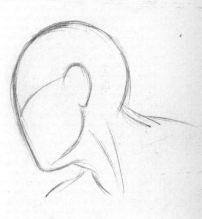

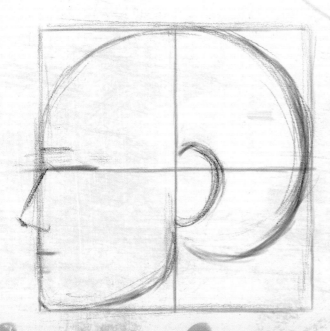

The head in profile fits roughly in a square. If centre lines are drawn in the square you can see that the ear falls behind the vertical centre with the top of the ear in line with the brow and the bottom in line with the base of the nose. The bottom of the skull lands on the same line as the mouth.

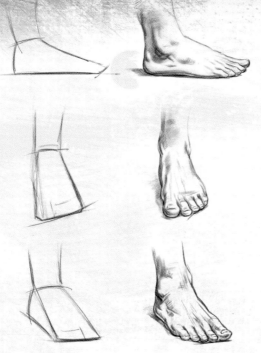

DRAWING THE FEET

The feet, like the hands, are much easier to draw when they are simplified into their basic shapes. The foot is a wedge shape that slightly curves at the tip, is longer on the side of the big toe and shorter on the side of the little toe. The foot is roughly the same length as the skull from top to chin. When drawing the detail, notice how the tip of the big toe points upwards, while the rest of the toes turn downwards, and that the inner ankle is higher than the outer.

DRAWING HANDS

Hands are very expressive and can show the mood of a character, so it's important to be able to draw them correctly. Drawing hands can be difficult, but there are ways to simplify the task. Sketching the hand as a mitten shape before adding the detail is one way, but this method is limited in its scope for complicated or dramatic hand gestures. For more complex hands, it may be helpful to break them down into their most basic shapes. The palm can be seen as a thick, roughly square-shaped plate while the fingers are thin cylinders protruding out of the plate, each finger made of three sections. The thumb emerges from a small triangle on the side of the plate starting halfway down the palm and the rest of the thumb is a short stubby cylinder made from two sections. Use your own hand as a model to practise with, and it may help to use a mirror for difficult poses.

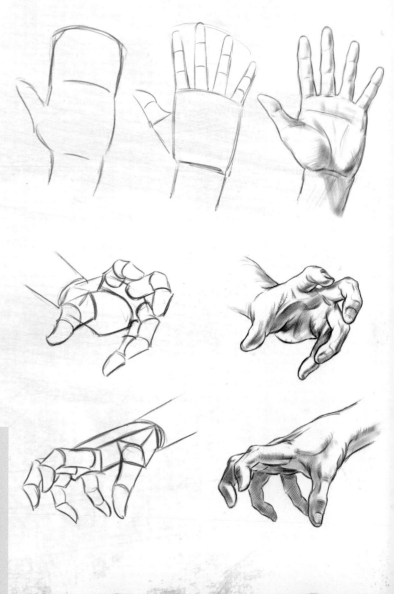

Checklist: Proportion

Here are a few measurements that will help keep your hands in proportion:

The length of the hand is the same as the distance between the chin and hairline

The width of the hand is the same as the distance from the nose to the chin

The middle finger, from knuckle to tip is the same length as the palm

MUSCULATURE

A mighty warrior needs to look tough and strong with a well-developed physique. To render this successfully, a basic knowledge and understanding of human musculature is necessary. Human musculature is a complex subject and it would take a whole book to cover it in detail, so here I will outline the major muscles and shapes that should be observed when drawing the figure. Male and female muscle structure is the same, although generally speaking the muscles of the male are more obviously defined and angular, while female musculature is smoother with softer contours.

FRONT TORSO

1- Serratus anterior muscle
2- Clavicle (collar bone)
3- Trapezius muscle
4- Pectorals
5- Abdominals

BACK TORSO

1- Trapezius muscle
2- Deltoid muscle
3- Scapula (shoulder blade)
4- Latissimus dorsi muscle
5- Sacrospinalis

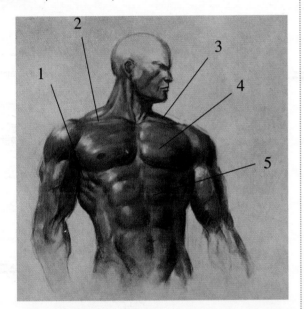

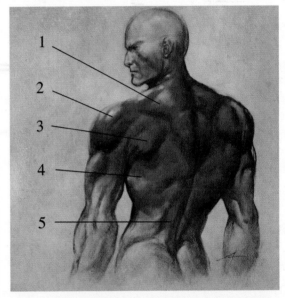

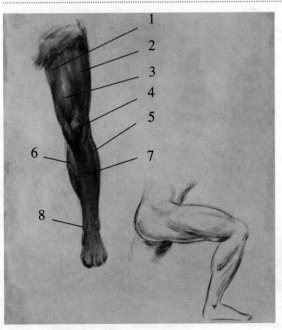

LEG

1- Adductors
2- Vastus externus
3- Vastus internus
4- Kneecap
5- Peroneus longus
6- Gastrocnemius
7- Tibia (shinbone)
8- Medial malleolus (ankle bone)

ARM

1- Deltoid muscle
2- Tricep muscle
3- Bicep muscle
4- Brachioradialis
5- Flexor carpi radialis
6- Extensor digitorum

Weapons

Weapons are the warrior's tools of the trade, but in many warrior cultures the weapon was far more than a dealer of death – it carried huge symbolic significance and was often imbued with spiritual qualities. They would be given names such as 'Leg biter' and 'Spine cleaver', and were passed down from father to son.

The wide variety of physical weapon design would have been constrained by considerations such as strength, weight and manoeuvrability. When designing weapons for purely artistic impact we need not be restricted by such constraints and can let our imagination run wild. As long as they look believable and not likely to shatter when used, then pretty much anything goes! Consider how your weapon will reflect the personality or culture of your warrior; a basic club or hammer could be indicative of a primitive, barbaric nature, while a long curved ornate sword would show that the warrior comes from a sophisticated culture. Here are some of the main categories of weapons.

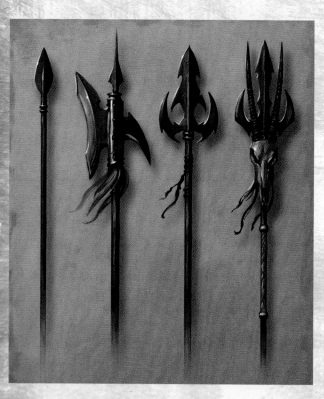

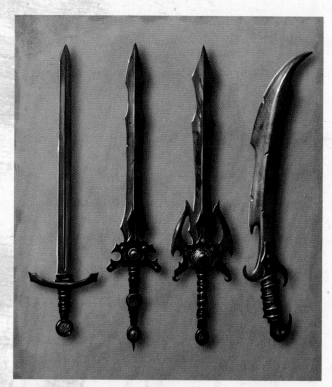

SPEARS AND HALBERDS

The spear has a long wooden shaft with a sharp metal tip at one end and is used for throwing and thrusting. Halberds are heavier with larger steel or iron heads and are used for crushing and piercing armour and for hooking riders from their horses. In the illustration you can see a variety of spears, pikes and halberds – one has an animal skull attached for effect and could be used for ceremonial rituals.

SWORDS

The hero's favourite, the sword has a long metal blade and a hilt with a guard to protect the hand. It's a versatile weapon used for thrusting and striking, it can be a large two-handed weapon or a smaller single-handed version allowing the warrior to carry a shield or another weapon. The blade can be straight or curved.

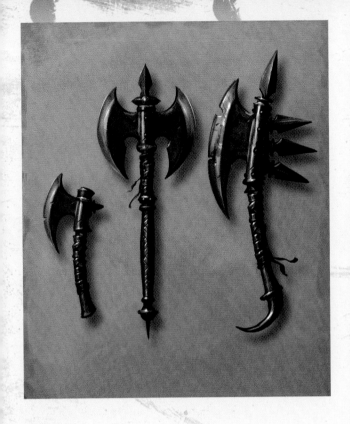

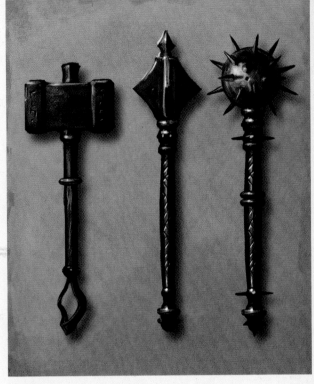

AXES

A small axe can be held in one hand and thrown at the enemy, while a larger double-headed battleaxe is heavier and requires the use of two hands. There is a lot of scope with the design of an axe head as you can cut and carve into the blade to make interesting shapes, as the final example shows.

HAMMERS AND MACES

Hammers are brutal weapons, used to crush the armour and bones of the enemy. A strap attached to the handle means they can be swung around on the battlefield. Maces are similar to hammers but have spikes or jagged edges designed to pierce through the armour embedding themselves into the wearer.

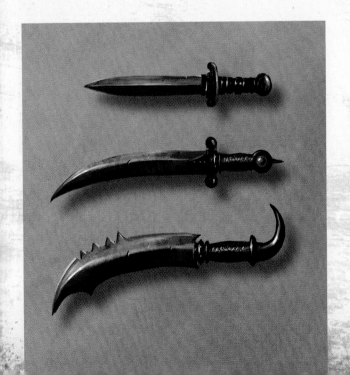

DAGGERS

Usually serving as a secondary weapon the dagger is useful for close quarter combat, cutting, thrusting and stabbing through the gaps in the opponent's armour. The dagger could be attached to a belt or hidden on the body and could be just as lethal as a larger weapon in skilful hands.

CREATING A WEAPON

STEP 1

Start building your weapon by drawing a line that indicates the basic direction of the weapon – a straight line if it is straight, or a curved line if it is curved.

STEP 2

Keeping your pencil lines light and free, loosely build your shape around the line, experimenting and erasing until you get a shape you are happy with.

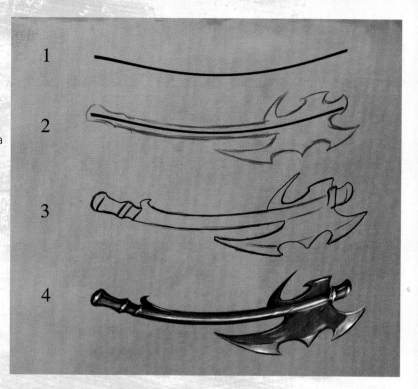

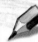

STEP 3

Tidy up the drawing and make sure that both sides are identical if your design is symmetrical.

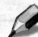

STEP 4

Block in your colours and embellish the design with more detail. Make sure you add bright highlights to give a metallic look, especially on the weapon's blade.

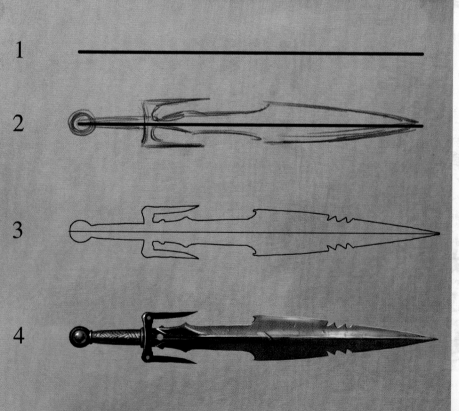

Colour Theory

Colour is one of the most powerful weapons in an artist's armoury. It's what brings a picture to life, and it can guide the viewer in their emotional response to an image. As with all aspects of art there are no hard and fast rules, but learning the basics of colour theory will help you to make effective choices when creating your warriors and their environments. Before getting to grips with the theory it's worth familiarizing yourself with some of the terms used.

Hue – another word for colour. Red, blue and green are all hues for example.

Tone/Value – how dark or light a colour is. Tones range from the brightest white to the darkest black, with mid tones in between.

Saturation – how bright or dull a colour is, saturated is vivid, while unsaturated is dull and grey.

Temperature – how warm or cool a colour is. Red, yellow and orange are warm colours, blue and green are cool colours.

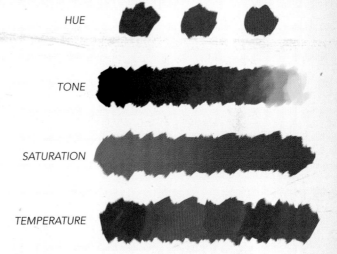

HUE

TONE

SATURATION

TEMPERATURE

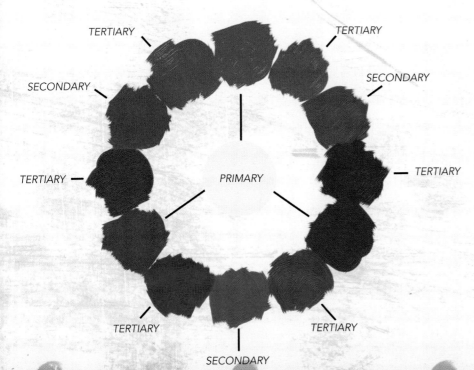

TERTIARY *TERTIARY*
SECONDARY *SECONDARY*
TERTIARY *TERTIARY*
PRIMARY
TERTIARY *TERTIARY*
SECONDARY

COLOUR WHEEL

The colour wheel is a circular arrangement of primary, secondary and tertiary colours, and is the most effective way to illustrate the theory of colour.

Primary Colours

Red, yellow and blue – a primary colour is one that cannot be created by mixing any combination of colours; instead they are the basis of all other colours. They are distributed evenly apart on the colour wheel.

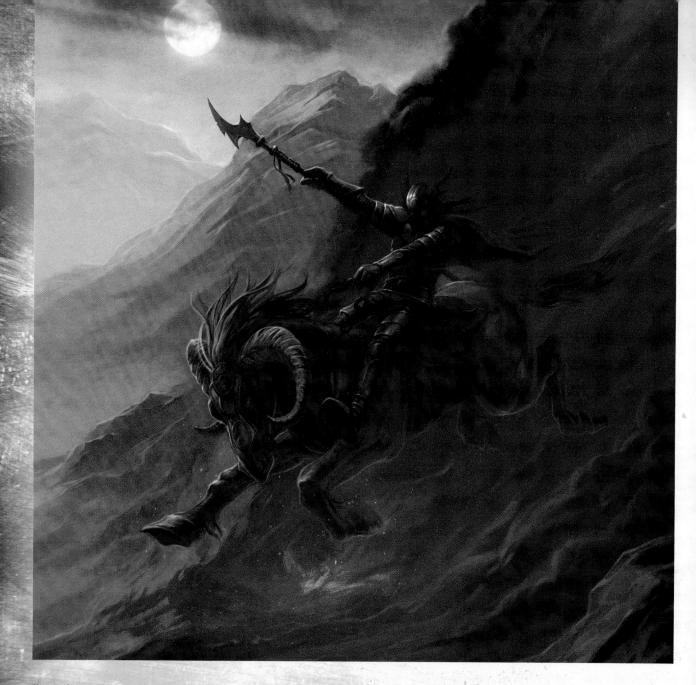

Secondary Colours

Green, purple and orange – a secondary colour is created by mixing two of the primary colours, for example red and yellow make orange.

Tertiary Colours

Yellow-orange, red-orange, red-purple, blue-purple, blue-green and yellow-green – tertiary colours are created by mixing one primary and one secondary colour together.

COLOUR RELATIONSHIPS

Colours react and interact with each other in different ways and it's possible to evaluate their relationship according to their position on the colour wheel.

Some colours contrast while others harmonize – an important factor when choosing a colour scheme.

Complementary Colours

Colours taken from opposite sides of the wheel are complementary – red complements green, for example. These colours have the strongest contrast and can create dynamic colour combinations when used together. A complementary colour scheme works best when one colour is chosen as the dominant colour and the other used to draw the attention of the viewer to where the action is.

The image above is an example of a complementary colour scheme: blue and orange are set against each other to maximize visual impact.

Harmonious Colours

Colours situated beside each other on the wheel, such as blue, blue-green and blue-purple, have the closest relationship and can be used to create a harmonious palette. A harmonious colour scheme is simple and pleasing to the eye but can be monotonous, so care must be taken to provide variety of tone and intensity.

Different tones of green create a harmonious scheme in this example. Even the warmer skin tone of the warrior has taken on a green tinge.

Limiting your palette to a few carefully chosen colours will produce far better results than a haphazard approach. Time spent planning the colour scheme at the beginning of each picture is time well spent. If in doubt, do a few colour roughs to help you visualize the end result.

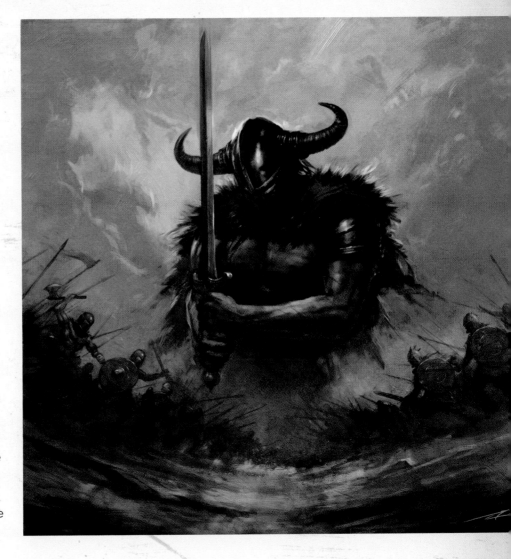

COLOUR MOOD

Colour has the power to create mood and atmosphere and, consciously or unconsciously, colour association can be used to provoke a strong response from the viewer.

Reds

The colour of danger and charged emotions. Vivid red is fiery hot and suggests energy, passion and destruction, it immediately grabs the viewer's attention.

Greens

The colour of nature, green represents life and is calm, passive and tranquil.

Yellows

Depending on the tone, yellow can be viewed as a happy 'sunshine' colour or a strong harsh colour, a warning, which can feel uncomfortable to look at.

Blues

Blue is a cold colour, deep and cool like the sea, or light and airy like the sky. Blues tend to recede into the distance so they make good background colours.

Lighting

Creative use of light can add dramatic impact to your art, and a good understanding of how light works will help with the successful shading and modelling of your figures.

Light emanates from a source in straight lines. When the light hits an object it illuminates the side it hits and casts a shadow on the opposite side. It is this effect of light and shade that defines the form of an object. There are two types of shadow – shadows caused as the forms slowly turn away from the light source creating the relief of an object, and shadows that are cast by an object or shape obscuring the light. We can study the effect of how light works by lighting a simple sphere. In the illustration the light source is coming from top left and is marked by a small arrow. The bright white highlight is where the light hits the object at full strength. From there it gradually lessens in strength as the shape of the sphere curves away from the light, forming a range of intermediate tones, before eventually falling into deep shadow on the opposite side. There is a reflected light in the shadow on the sphere, which is caused by light bouncing up from the surface the sphere is sitting on. Reflected lights are important for creating the illusion of roundness and volume. Also, notice that the sphere is stopping the light reaching the surface it's sitting on, therefore casting a shadow on the surface.

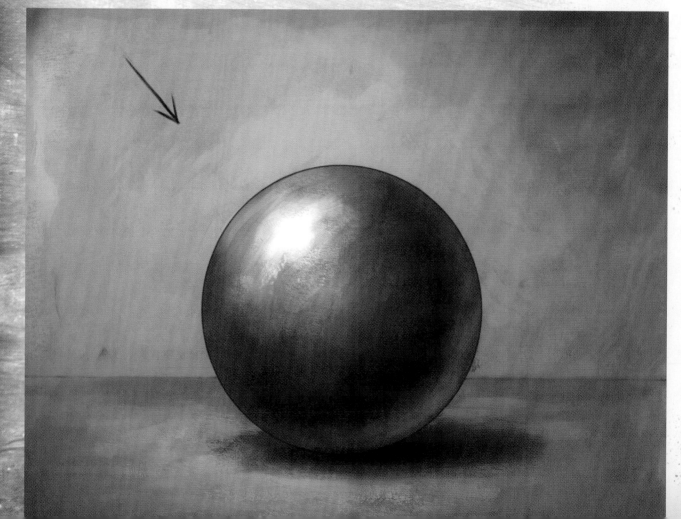

Where you place your light source will dramatically affect the way your warrior will look as these examples show.

With the light coming from above, the figure is given an almost god-like appearance; shadows are cast downwards and the eyes are in darkness giving a mysterious look to the character.

Lit from the side the features are delineated and the muscles are well defined.

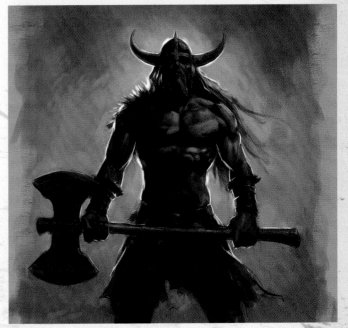

Bottom lighting is a standard device used to create a dark, sinister look.

Backlighting creates a silhouette, and works best when the figure has an interesting outline, perhaps with lots of spikes or horns.

Barbarian

Throughout history the barbarians have struck fear into the hearts of civilised people. Brutal and savage, these uncivilised, fearsome warriors would destroy anyone and anything in their search for plunder and glory. The fantasy barbarian is usually depicted as a tough lone figure, primitive in need and nature. A ruthless killer with a huge muscular build, he relies on brute strength rather than skill and cunning to get the job done.

'War is the business of barbarians'

Napoleon Bonaparte

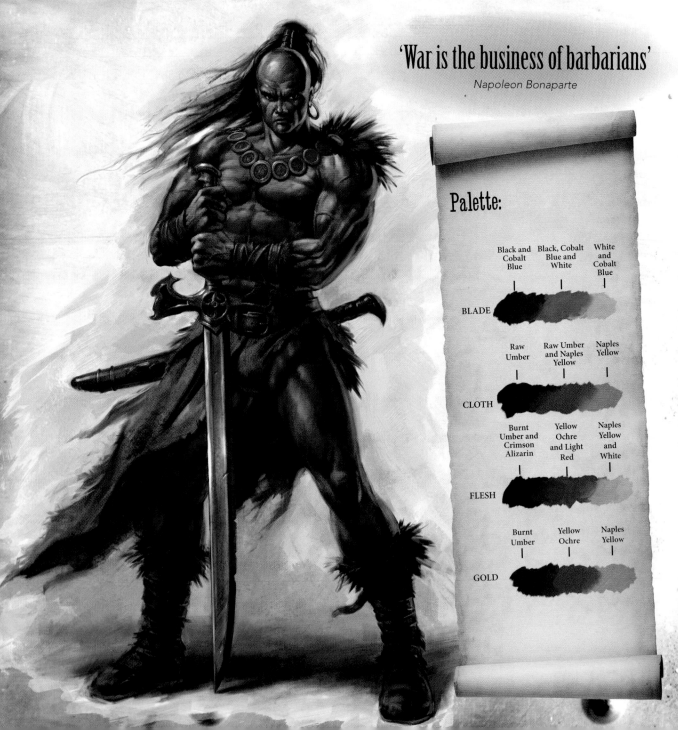

Palette:

	Black and Cobalt Blue	Black, Cobalt Blue and White	White and Cobalt Blue
BLADE			
	Raw Umber	Raw Umber and Naples Yellow	Naples Yellow
CLOTH			
	Burnt Umber and Crimson Alizarin	Yellow Ochre and Light Red	Naples Yellow and White
FLESH			
	Burnt Umber	Yellow Ochre	Naples Yellow
GOLD			

Use basic, suggestive shapes to indicate the pelvis and rib cage areas.

STEP 1

Start with a basic stick figure, drawing the head and spine line. He is going to have a broad stature so keep this in mind while drawing. Your lines should be loose and faint at this stage, and don't worry if you do not get it right the first time – just be sure to erase any lines that you don't want as you go. The more you practise drawing this early, developmental stage, the more instinctive it will become, so stick with it!

Draw the limbs as very thin cylinders or tubes, with small circles indicating the joints.

STEP 2

It's important to get the proportions and lengths of all elements correct using the head as the measurement (see p. 14). Once you are happy with the general pose, add form and mass to the figure using larger cylinder shapes.

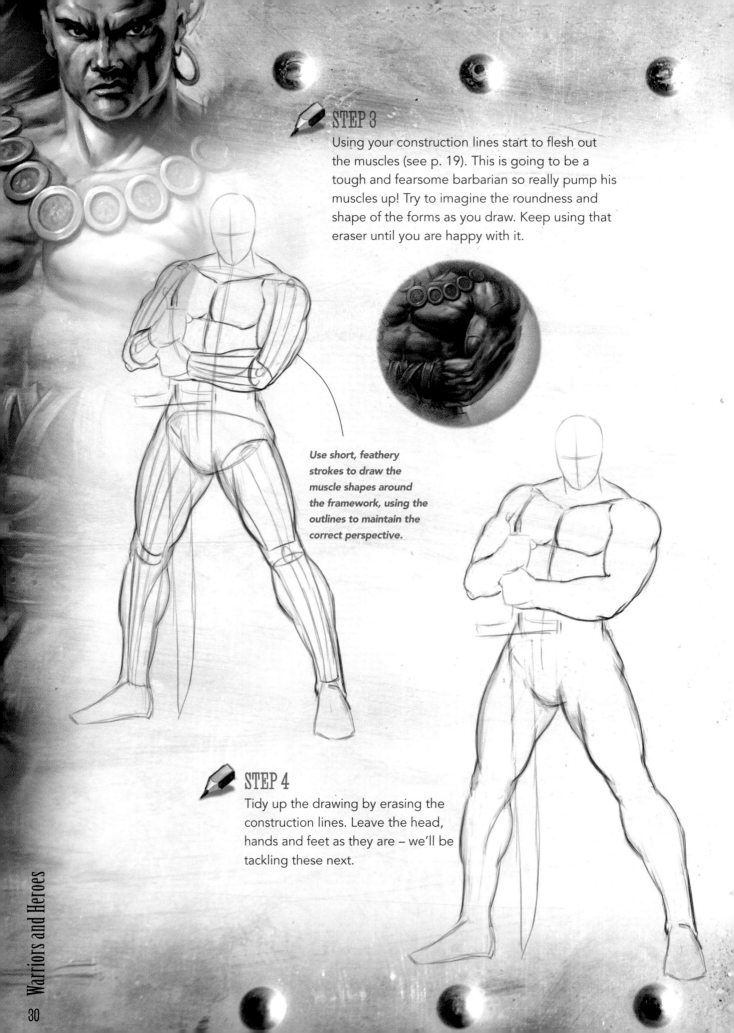

STEP 3

Using your construction lines start to flesh out the muscles (see p. 19). This is going to be a tough and fearsome barbarian so really pump his muscles up! Try to imagine the roundness and shape of the forms as you draw. Keep using that eraser until you are happy with it.

Use short, feathery strokes to draw the muscle shapes around the framework, using the outlines to maintain the correct perspective.

STEP 4

Tidy up the drawing by erasing the construction lines. Leave the head, hands and feet as they are – we'll be tackling these next.

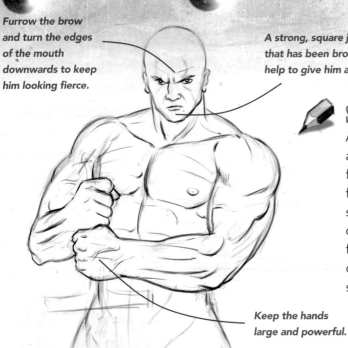

Furrow the brow and turn the edges of the mouth downwards to keep him looking fierce.

A strong, square jaw and a large, flat nose that has been broken in many a battle will help to give him a thug-like appearance.

STEP 5

Add in the facial features, thinking all the time about the kind of face you want this mean, fearsome aggressor to have. Try to make his features harsh and brutal. Correct the muscle shapes if necessary, and start adding more muscle detail to the arms and legs. It's good to draw the feet in detail, even though they're going to be covered by boots, so that you retain their correct shape throughout.

Keep the hands large and powerful.

Give any loose flowing elements, such as hair or cloth, some movement, as if blowing in the wind. This will add dynamism to an otherwise static image.

STEP 6

Now it's time to put some clothes on your barbarian. Keep it simple, just some fur, torn cloth and basic adornments, and use references to help you get the look right. A giant two-handed sword will keep his enemies at bay, and a single-handed sword strapped to his belt will act as a backup weapon.

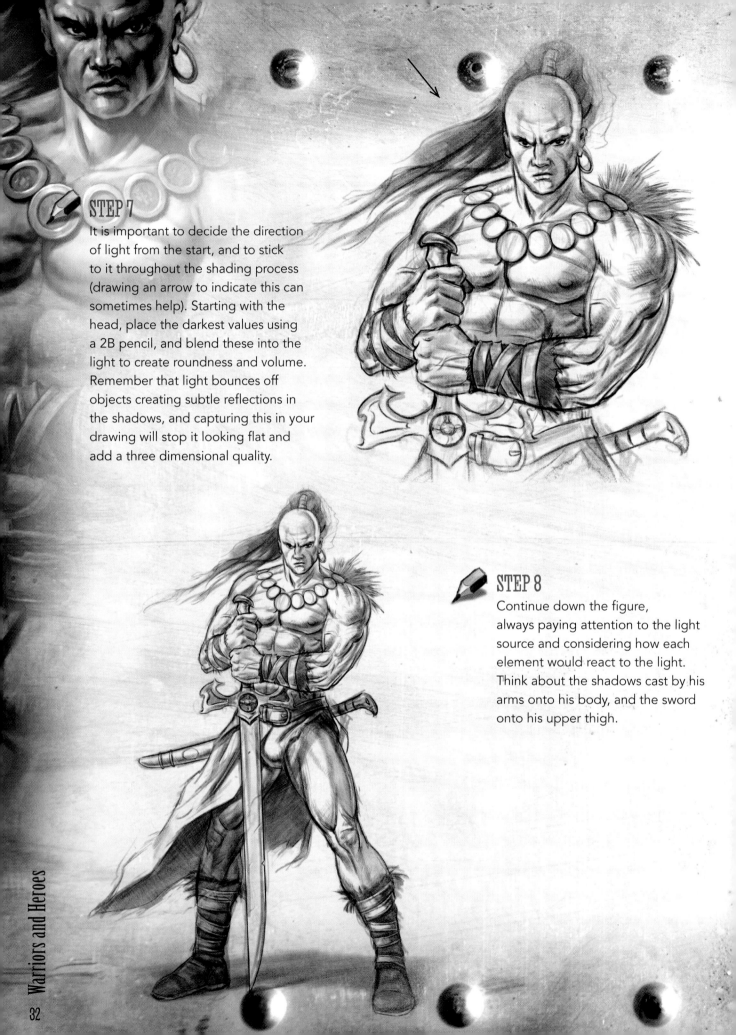

STEP 7

It is important to decide the direction of light from the start, and to stick to it throughout the shading process (drawing an arrow to indicate this can sometimes help). Starting with the head, place the darkest values using a 2B pencil, and blend these into the light to create roundness and volume. Remember that light bounces off objects creating subtle reflections in the shadows, and capturing this in your drawing will stop it looking flat and add a three dimensional quality.

STEP 8

Continue down the figure, always paying attention to the light source and considering how each element would react to the light. Think about the shadows cast by his arms onto his body, and the sword onto his upper thigh.

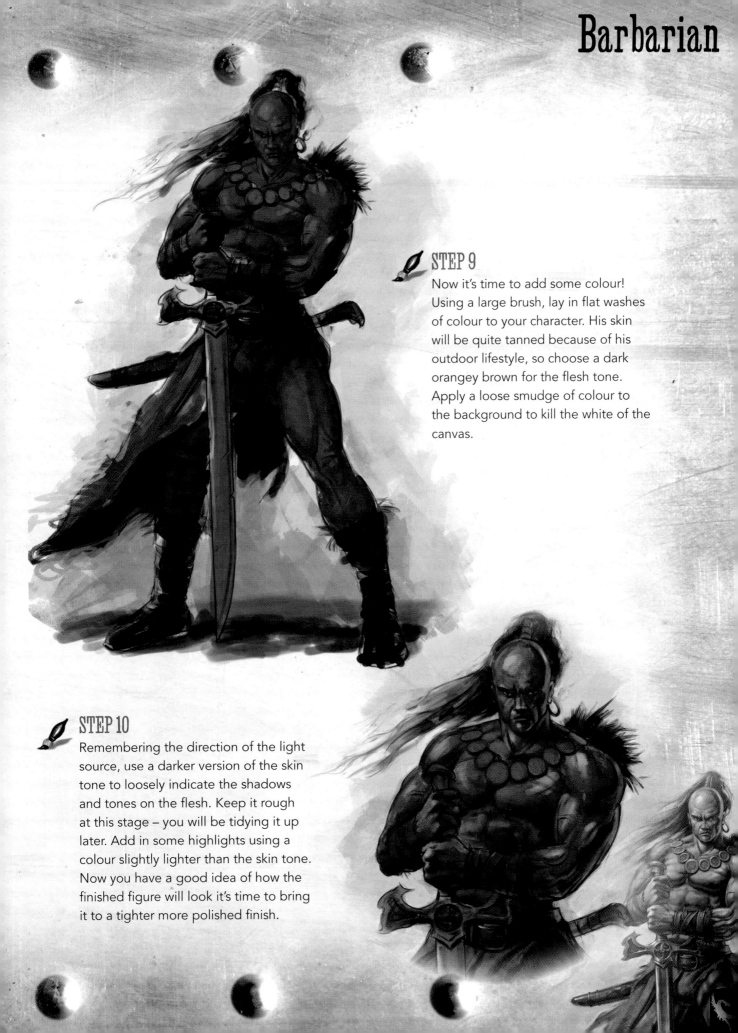

STEP 9

Now it's time to add some colour! Using a large brush, lay in flat washes of colour to your character. His skin will be quite tanned because of his outdoor lifestyle, so choose a dark orangey brown for the flesh tone. Apply a loose smudge of colour to the background to kill the white of the canvas.

STEP 10

Remembering the direction of the light source, use a darker version of the skin tone to loosely indicate the shadows and tones on the flesh. Keep it rough at this stage – you will be tidying it up later. Add in some highlights using a colour slightly lighter than the skin tone. Now you have a good idea of how the finished figure will look it's time to bring it to a tighter more polished finish.

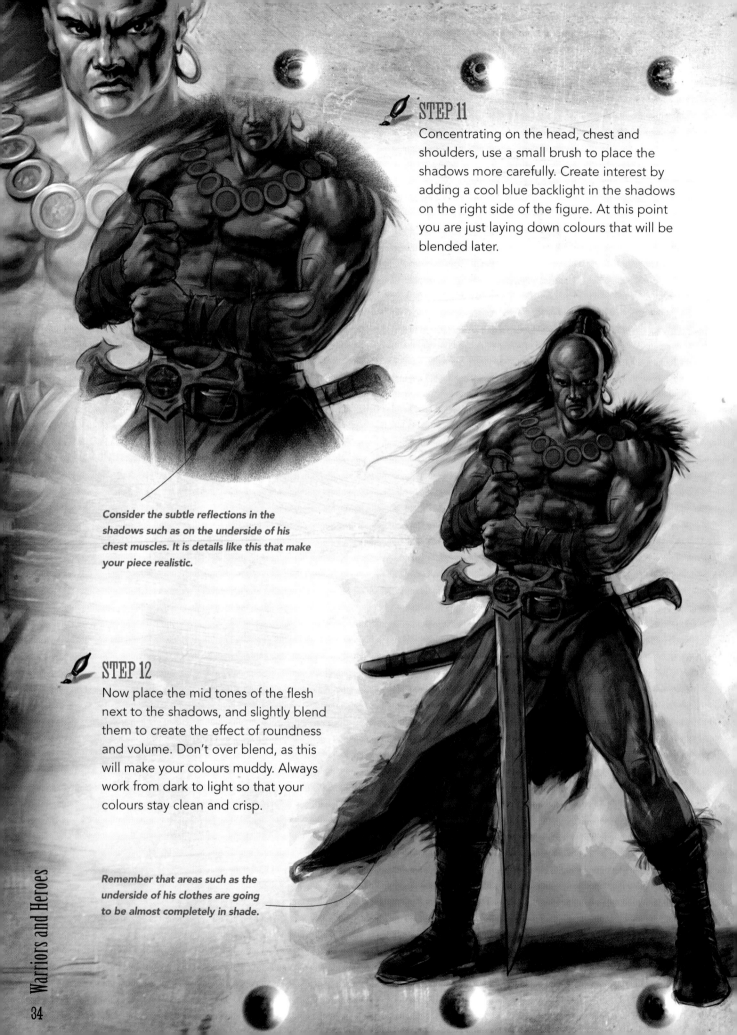

STEP 11

Concentrating on the head, chest and shoulders, use a small brush to place the shadows more carefully. Create interest by adding a cool blue backlight in the shadows on the right side of the figure. At this point you are just laying down colours that will be blended later.

Consider the subtle reflections in the shadows such as on the underside of his chest muscles. It is details like this that make your piece realistic.

STEP 12

Now place the mid tones of the flesh next to the shadows, and slightly blend them to create the effect of roundness and volume. Don't over blend, as this will make your colours muddy. Always work from dark to light so that your colours stay clean and crisp.

Remember that areas such as the underside of his clothes are going to be almost completely in shade.

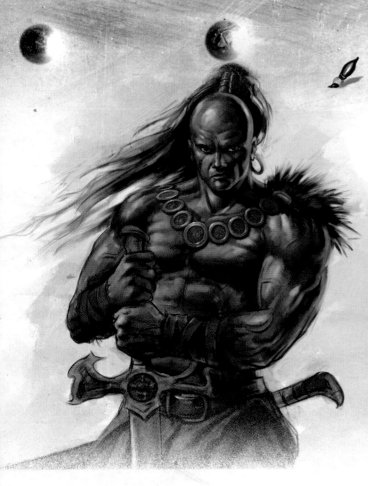

STEP 13

Highlights really bring the character to life, and now is the time to add these. Work boldly but sparingly, as too many will spoil the effect. Dab the lights on using a colour much lighter than the mid tone (a mix of mid tone, white and yellow) and don't blend these too much as this will lessen their impact.

Artist's tip

Use a small detail brush to redraw or correct any details and to paint the gold ornament around his neck.

STEP 14

Continue painting the rest of the flesh, adding shadows first, followed by the mid tones and finally the highlights. The highlights become less bright as you get further from the light source, so keep his legs relatively dark.

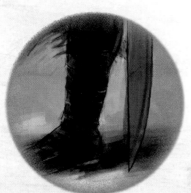

As you get further away from the light source the highlights will appear less. Bear this in mind when you come to his legs, feet and the tip of the sword.

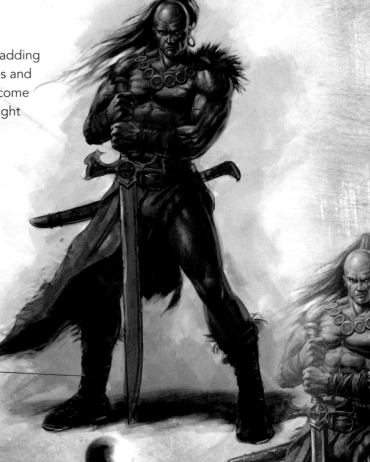

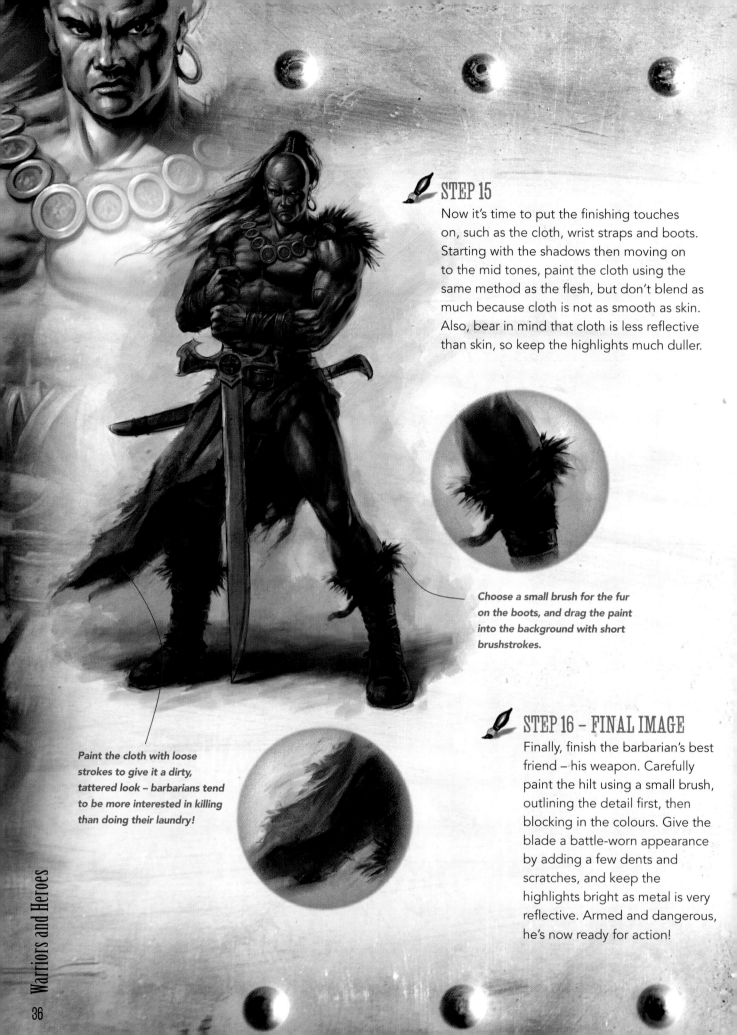

STEP 15

Now it's time to put the finishing touches on, such as the cloth, wrist straps and boots. Starting with the shadows then moving on to the mid tones, paint the cloth using the same method as the flesh, but don't blend as much because cloth is not as smooth as skin. Also, bear in mind that cloth is less reflective than skin, so keep the highlights much duller.

Choose a small brush for the fur on the boots, and drag the paint into the background with short brushstrokes.

Paint the cloth with loose strokes to give it a dirty, tattered look – barbarians tend to be more interested in killing than doing their laundry!

STEP 16 – FINAL IMAGE

Finally, finish the barbarian's best friend – his weapon. Carefully paint the hilt using a small brush, outlining the detail first, then blocking in the colours. Give the blade a battle-worn appearance by adding a few dents and scratches, and keep the highlights bright as metal is very reflective. Armed and dangerous, he's now ready for action!

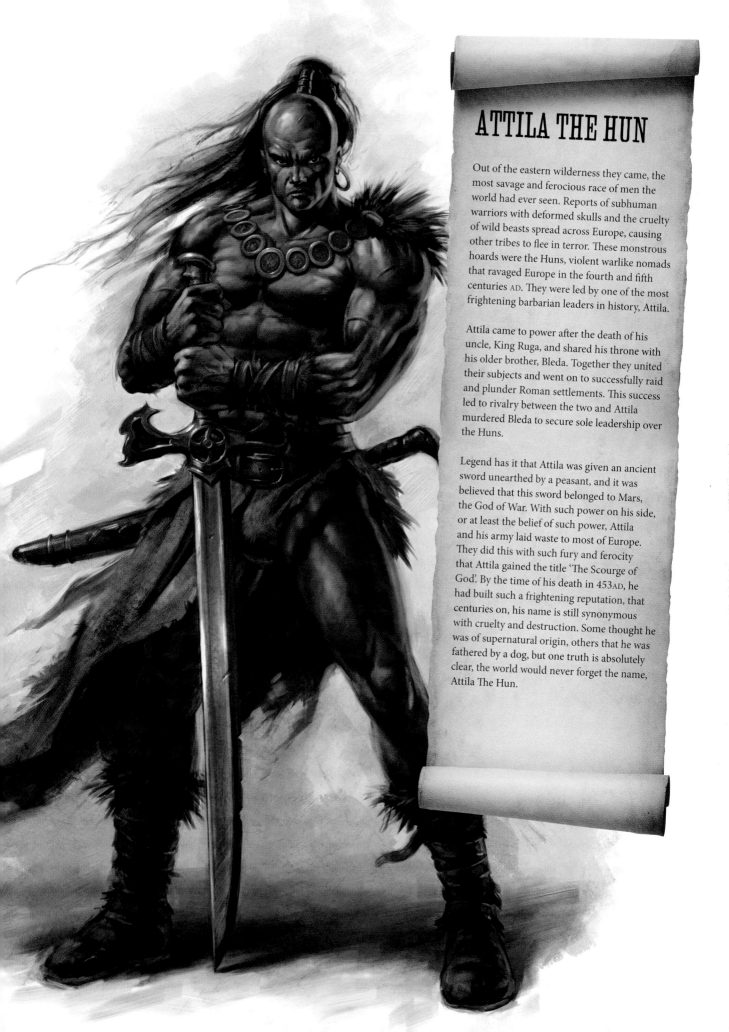

ATTILA THE HUN

Out of the eastern wilderness they came, the most savage and ferocious race of men the world had ever seen. Reports of subhuman warriors with deformed skulls and the cruelty of wild beasts spread across Europe, causing other tribes to flee in terror. These monstrous hoards were the Huns, violent warlike nomads that ravaged Europe in the fourth and fifth centuries AD. They were led by one of the most frightening barbarian leaders in history, Attila.

Attila came to power after the death of his uncle, King Ruga, and shared his throne with his older brother, Bleda. Together they united their subjects and went on to successfully raid and plunder Roman settlements. This success led to rivalry between the two and Attila murdered Bleda to secure sole leadership over the Huns.

Legend has it that Attila was given an ancient sword unearthed by a peasant, and it was believed that this sword belonged to Mars, the God of War. With such power on his side, or at least the belief of such power, Attila and his army laid waste to most of Europe. They did this with such fury and ferocity that Attila gained the title 'The Scourge of God'. By the time of his death in 453AD, he had built such a frightening reputation, that centuries on, his name is still synonymous with cruelty and destruction. Some thought he was of supernatural origin, others that he was fathered by a dog, but one truth is absolutely clear, the world would never forget the name, Attila The Hun.

Boudicca

This formidable Celtic warrior queen from ancient British history captures the imagination of all who hear her story. After the death of her husband Prasutagus, King of the Iceni, the Romans annexed the land of the Iceni tribe and flogged and tortured Boudicca and her daughters. Boudicca retaliated by uniting neighbouring tribes and, against all odds, she led a rebellion against the Roman Empire. With her following of tribal warriors she destroyed Colchester, London and St Albans before being defeated by the Romans. 'She was very tall and her aspect was terrifying, for her eyes flashed fiercely.' This description of Boudicca from a Roman Historian, only serves to strengthen the image suggested by her feats. Boudicca's name is the Celtic word for 'Victory' and although, ultimately, the Romans defeated her, her campaigns against them are renowned for the destruction and the scale of slaughter in what turned out to be the last organised resistance to the Roman occupation of Britain.

'Rome shall perish — write that word in the blood that she has spilt'
William Cowper, 1782

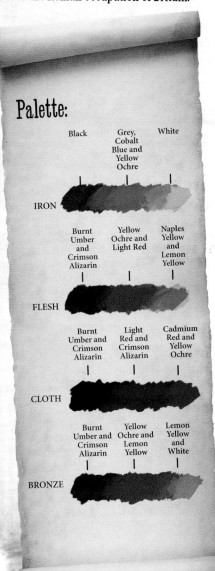

Palette:

	Black	Grey, Cobalt Blue and Yellow Ochre	White
IRON			

	Burnt Umber and Crimson Alizarin	Yellow Ochre and Light Red	Naples Yellow and Lemon Yellow
FLESH			

	Burnt Umber and Crimson Alizarin	Light Red and Crimson Alizarin	Cadmium Red and Yellow Ochre
CLOTH			

	Burnt Umber and Crimson Alizarin	Yellow Ochre and Lemon Yellow	Lemon Yellow and White
BRONZE			

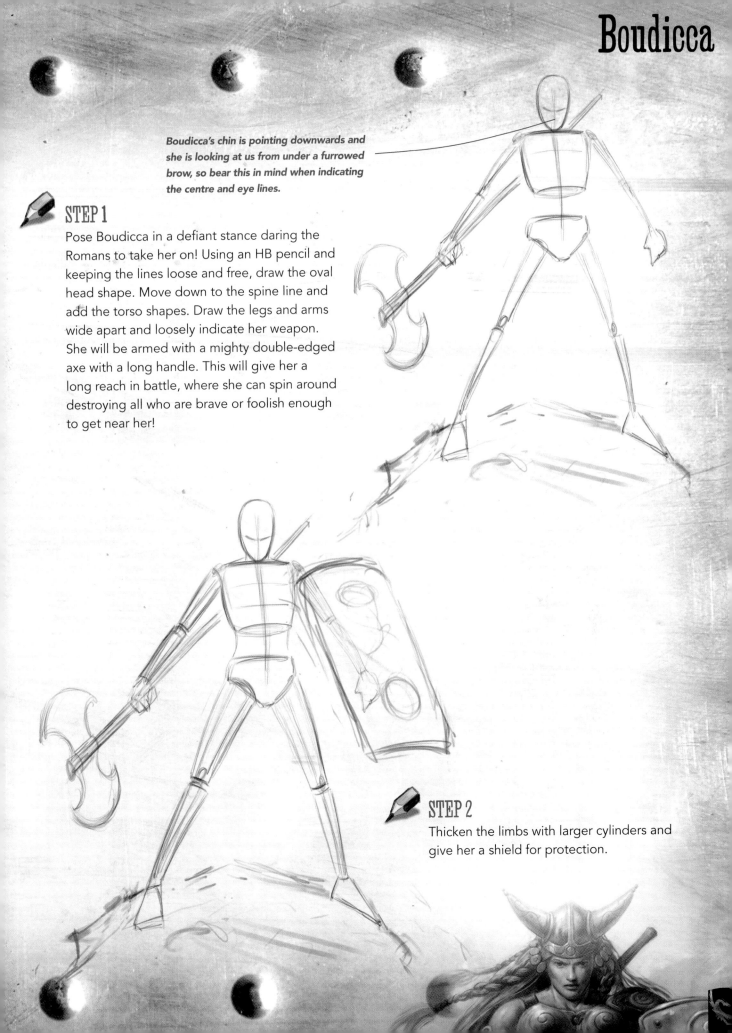

Boudicca

Boudicca's chin is pointing downwards and she is looking at us from under a furrowed brow, so bear this in mind when indicating the centre and eye lines.

STEP 1

Pose Boudicca in a defiant stance daring the Romans to take her on! Using an HB pencil and keeping the lines loose and free, draw the oval head shape. Move down to the spine line and add the torso shapes. Draw the legs and arms wide apart and loosely indicate her weapon. She will be armed with a mighty double-edged axe with a long handle. This will give her a long reach in battle, where she can spin around destroying all who are brave or foolish enough to get near her!

STEP 2

Thicken the limbs with larger cylinders and give her a shield for protection.

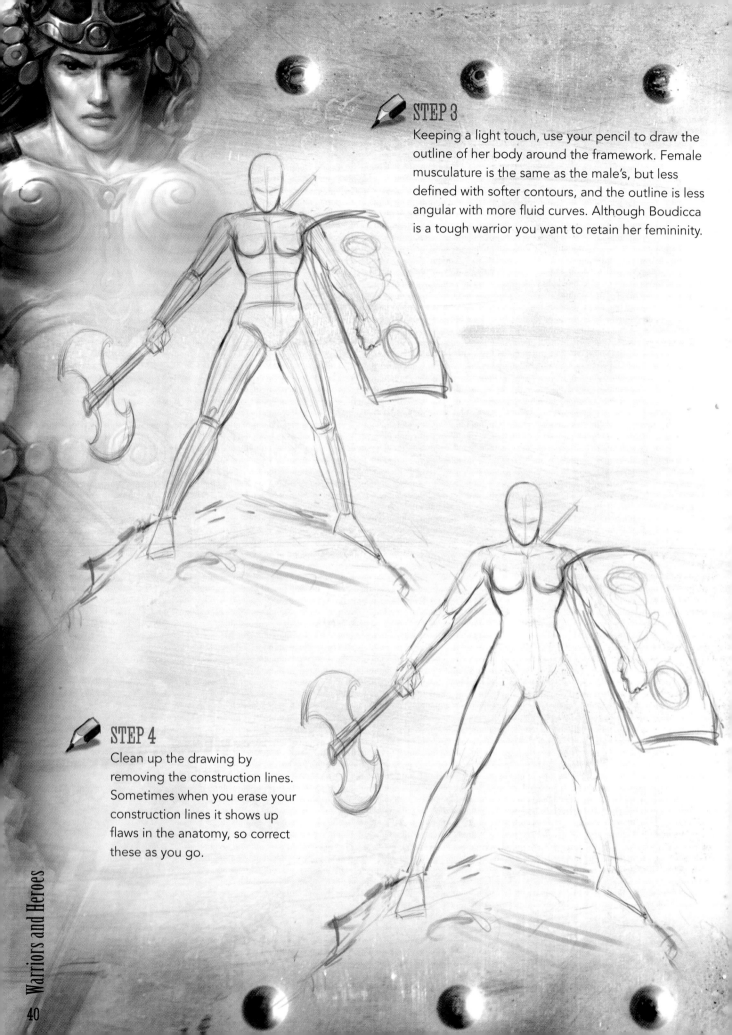

STEP 3

Keeping a light touch, use your pencil to draw the outline of her body around the framework. Female musculature is the same as the male's, but less defined with softer contours, and the outline is less angular with more fluid curves. Although Boudicca is a tough warrior you want to retain her femininity.

STEP 4

Clean up the drawing by removing the construction lines. Sometimes when you erase your construction lines it shows up flaws in the anatomy, so correct these as you go.

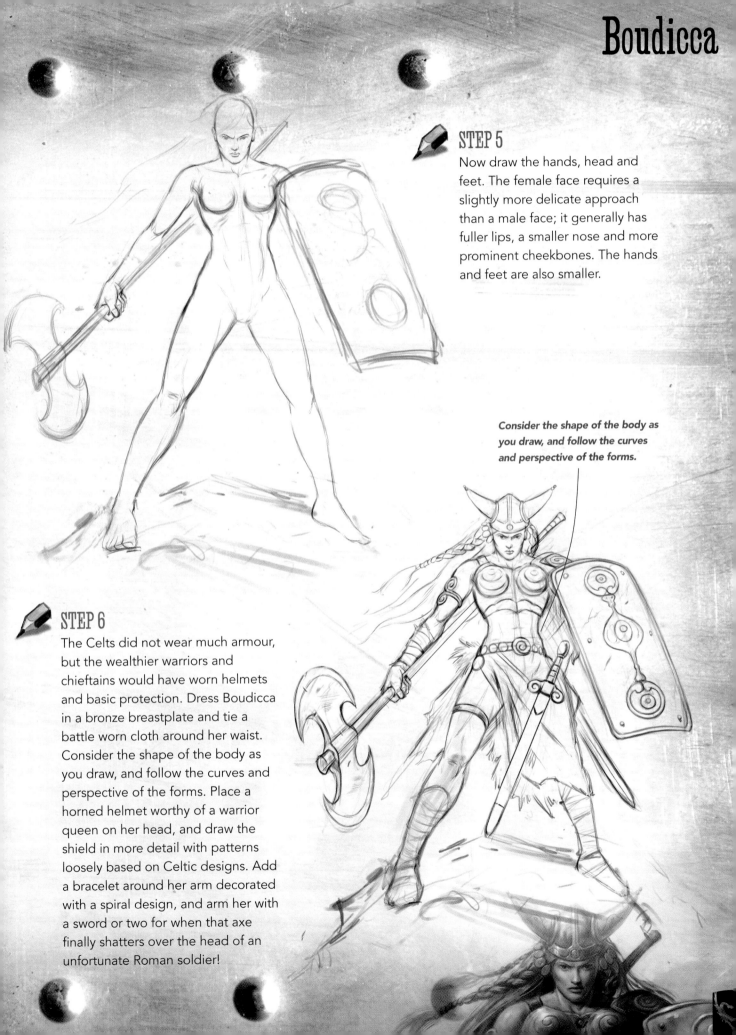

STEP 5

Now draw the hands, head and feet. The female face requires a slightly more delicate approach than a male face; it generally has fuller lips, a smaller nose and more prominent cheekbones. The hands and feet are also smaller.

Consider the shape of the body as you draw, and follow the curves and perspective of the forms.

STEP 6

The Celts did not wear much armour, but the wealthier warriors and chieftains would have worn helmets and basic protection. Dress Boudicca in a bronze breastplate and tie a battle worn cloth around her waist. Consider the shape of the body as you draw, and follow the curves and perspective of the forms. Place a horned helmet worthy of a warrior queen on her head, and draw the shield in more detail with patterns loosely based on Celtic designs. Add a bracelet around her arm decorated with a spiral design, and arm her with a sword or two for when that axe finally shatters over the head of an unfortunate Roman soldier!

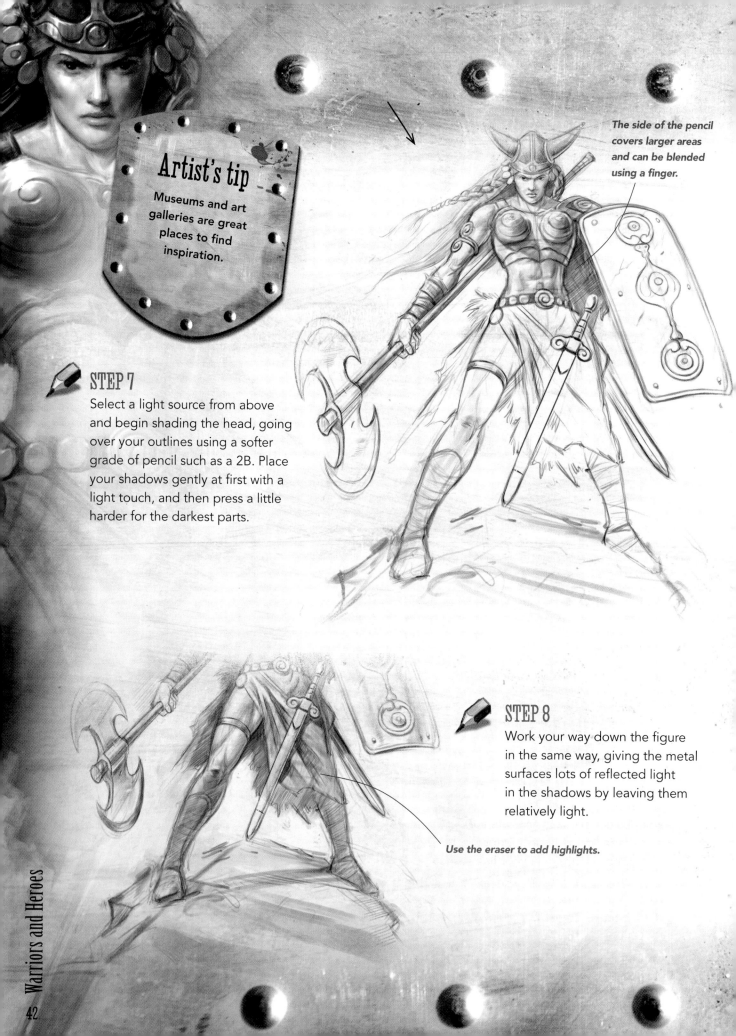

Artist's tip

Museums and art galleries are great places to find inspiration.

STEP 7

Select a light source from above and begin shading the head, going over your outlines using a softer grade of pencil such as a 2B. Place your shadows gently at first with a light touch, and then press a little harder for the darkest parts.

STEP 8

Work your way down the figure in the same way, giving the metal surfaces lots of reflected light in the shadows by leaving them relatively light.

Use the eraser to add highlights.

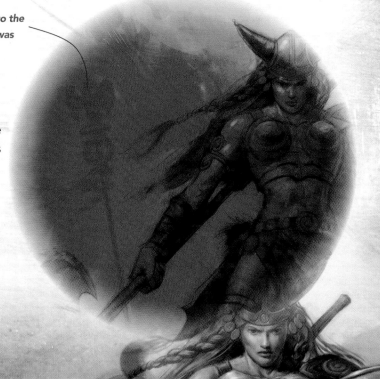

STEP 9

Roughly block in colour with large brushes; a bright yellow-orange colour scheme will be striking. Each colour used takes on the hue of the background, so as the colour here is yellow, every colour from the skin tone to the cloth colour will have a yellowish tinge.

The Standard was a powerful symbol to the Roman soldiers and losing it in battle was considered the ultimate humiliation.

 ## STEP 10

As you block in the background allow the shapes and colour to suggest themselves to create a balanced and harmonious composition. Loosely indicate light and shade on the figure by applying appropriate tones over your flat washes using the shaded drawing as a guide. Tidy up the background and add a Roman Standard.

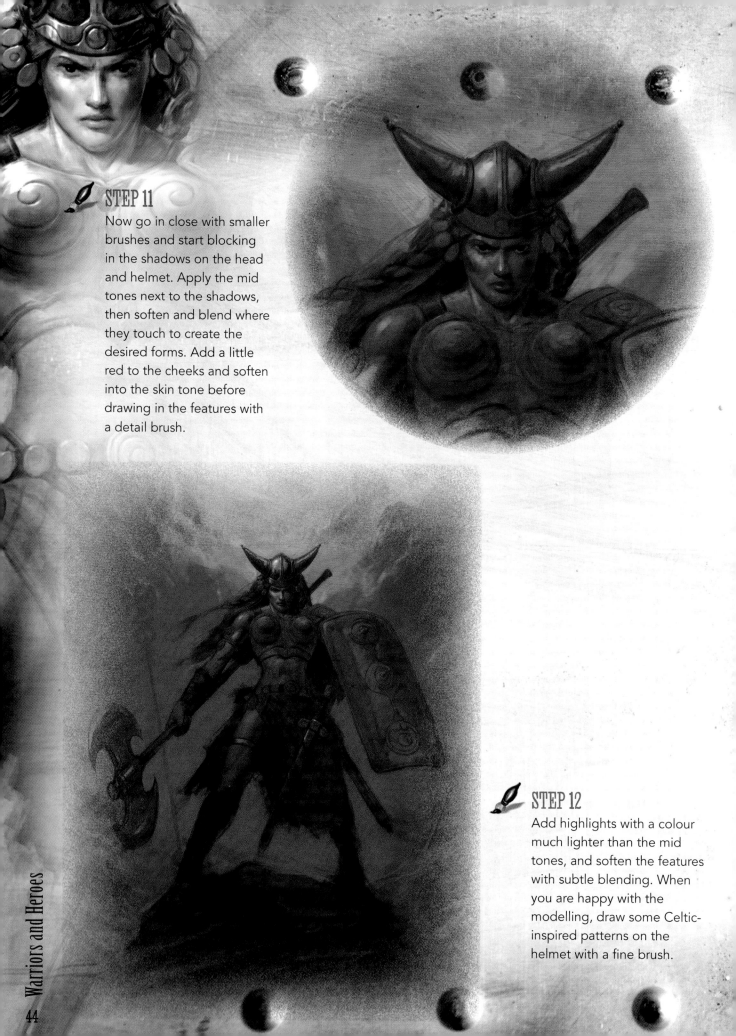

STEP 11

Now go in close with smaller brushes and start blocking in the shadows on the head and helmet. Apply the mid tones next to the shadows, then soften and blend where they touch to create the desired forms. Add a little red to the cheeks and soften into the skin tone before drawing in the features with a detail brush.

STEP 12

Add highlights with a colour much lighter than the mid tones, and soften the features with subtle blending. When you are happy with the modelling, draw some Celtic-inspired patterns on the helmet with a fine brush.

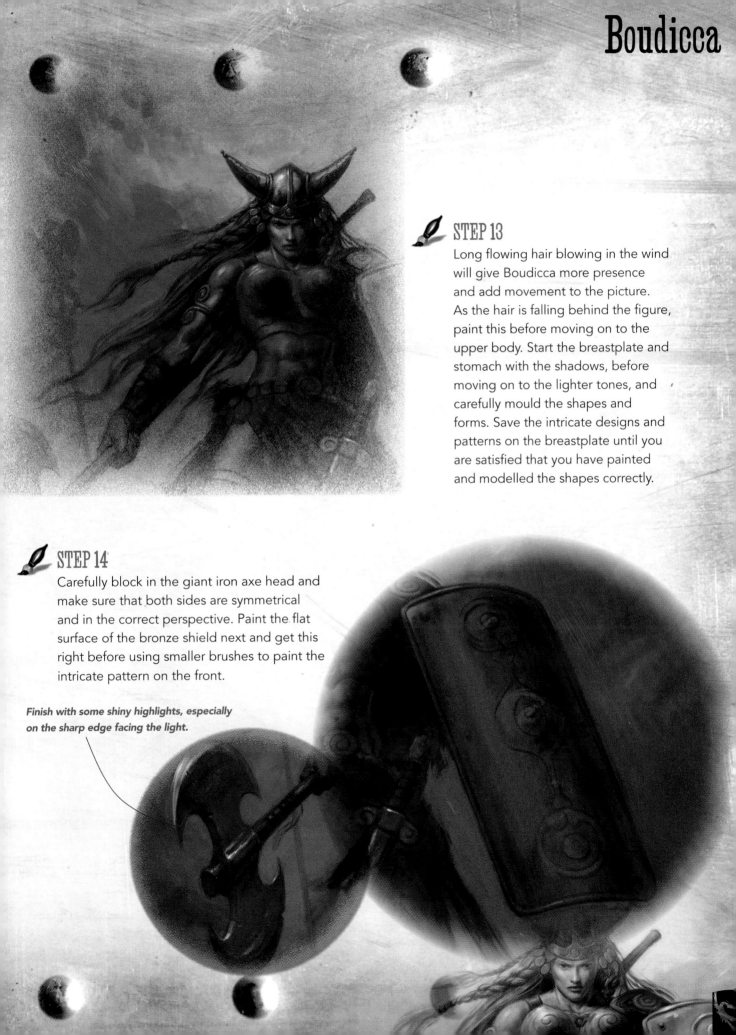

STEP 13

Long flowing hair blowing in the wind will give Boudicca more presence and add movement to the picture. As the hair is falling behind the figure, paint this before moving on to the upper body. Start the breastplate and stomach with the shadows, before moving on to the lighter tones, and carefully mould the shapes and forms. Save the intricate designs and patterns on the breastplate until you are satisfied that you have painted and modelled the shapes correctly.

STEP 14

Carefully block in the giant iron axe head and make sure that both sides are symmetrical and in the correct perspective. Paint the flat surface of the bronze shield next and get this right before using smaller brushes to paint the intricate pattern on the front.

Finish with some shiny highlights, especially on the sharp edge facing the light.

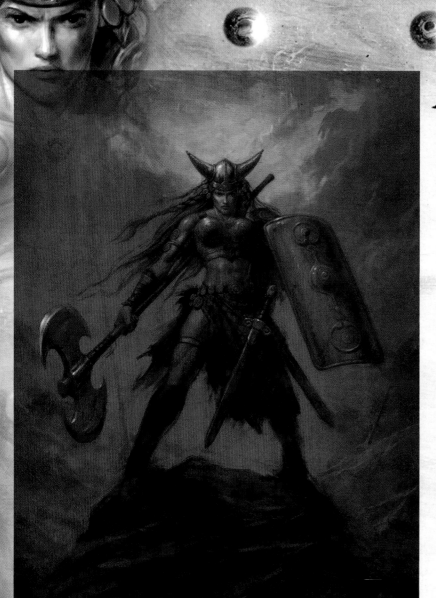

 ## STEP 15

As you want the viewer to focus on her face and upper body keep the brushwork loose and lively as you go further down the body. This will help to direct the eye to the tighter finished areas. Paint the cloth and folds keeping it quite tatty and battle torn, and then add a checked pattern for a bit of Celtic flavour, using references as necessary. When the cloth is done paint the swords and belt.

Artist's tip

Observe how different materials and surfaces reflect light, and portray this to achieve realism in your work.

STEP 16 – FINAL IMAGE

Apart from the thigh that is catching the light, keep the legs dark and in shadow and keep the brushwork loose. Once the image is finished, stand back from the picture or have a break and come back with fresh eyes to see if there are any flaws that need correcting. Boudicca, the great warrior queen of the Iceni, is now ready to take on the might of the Roman Empire, and to secure her place in history!

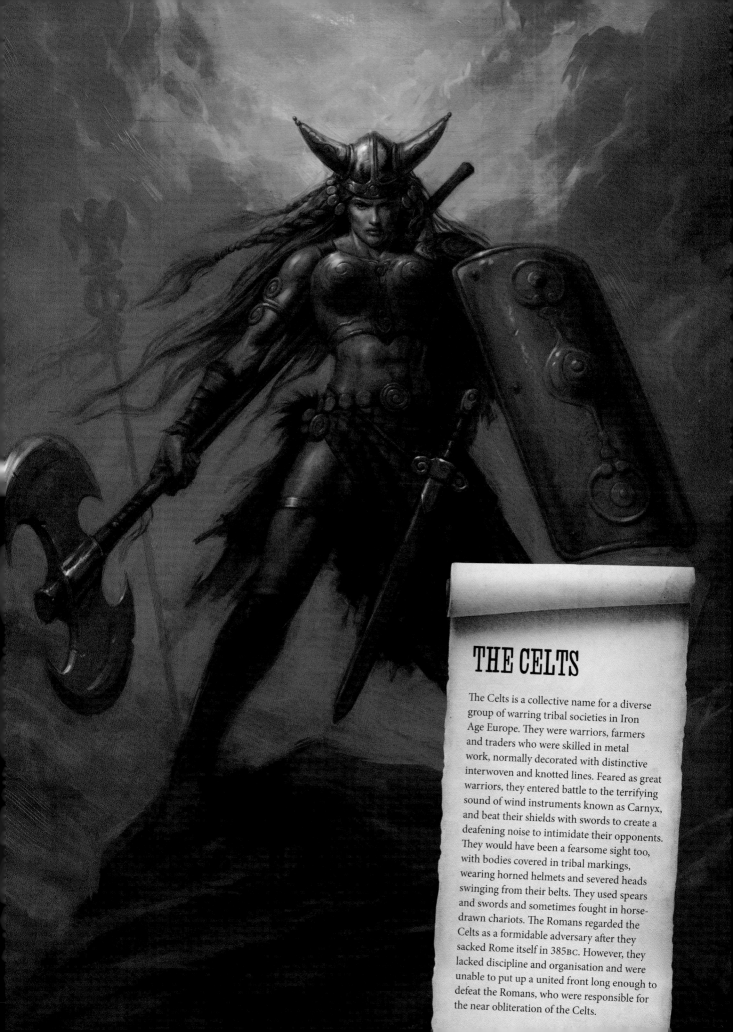

THE CELTS

The Celts is a collective name for a diverse group of warring tribal societies in Iron Age Europe. They were warriors, farmers and traders who were skilled in metal work, normally decorated with distinctive interwoven and knotted lines. Feared as great warriors, they entered battle to the terrifying sound of wind instruments known as Carnyx, and beat their shields with swords to create a deafening noise to intimidate their opponents. They would have been a fearsome sight too, with bodies covered in tribal markings, wearing horned helmets and severed heads swinging from their belts. They used spears and swords and sometimes fought in horse-drawn chariots. The Romans regarded the Celts as a formidable adversary after they sacked Rome itself in 385BC. However, they lacked discipline and organisation and were unable to put up a united front long enough to defeat the Romans, who were responsible for the near obliteration of the Celts.

Elven Archer

Minor gods of nature and fertility, elves have their roots in Germanic and Norse mythology, but influenced by the work of J.R.R. Tolkien and C.S. Lewis, elves have been adapted and modified to become a mainstay of the modern fantasy genre. Elves are depicted as otherworldly creatures, usually immortal and with magical powers. They are beautiful, gentle and wise. Death and disease do not plague them, so they grow old in years but remain looking young. Dwelling in forests and mossy woodlands, they fight only to defend their homes and for the greater good, but once provoked into battle they are strong opponents and generally emerge victorious.

'How, winged with fate, their elf-shot arrows fly'

William Collins, 1750

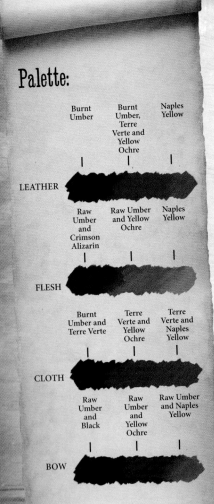

Palette:

	LEATHER		
	Burnt Umber	Burnt Umber, Terre Verte and Yellow Ochre	Naples Yellow

	FLESH		
	Raw Umber and Crimson Alizarin	Raw Umber and Yellow Ochre	Naples Yellow

	CLOTH		
	Burnt Umber and Terre Verte	Terre Verte and Yellow Ochre	Terre Verte and Naples Yellow

	BOW		
	Raw Umber and Black	Raw Umber and Yellow Ochre	Raw Umber and Naples Yellow

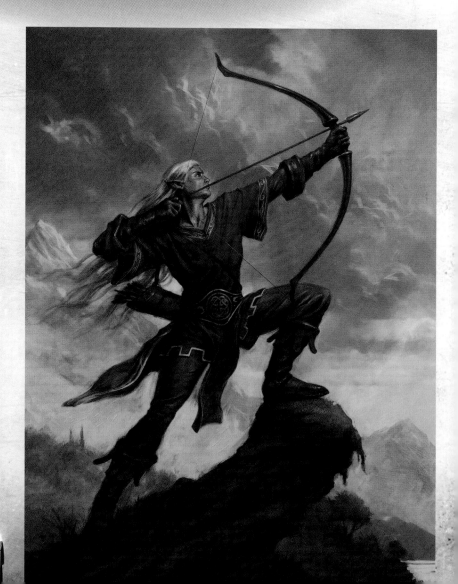

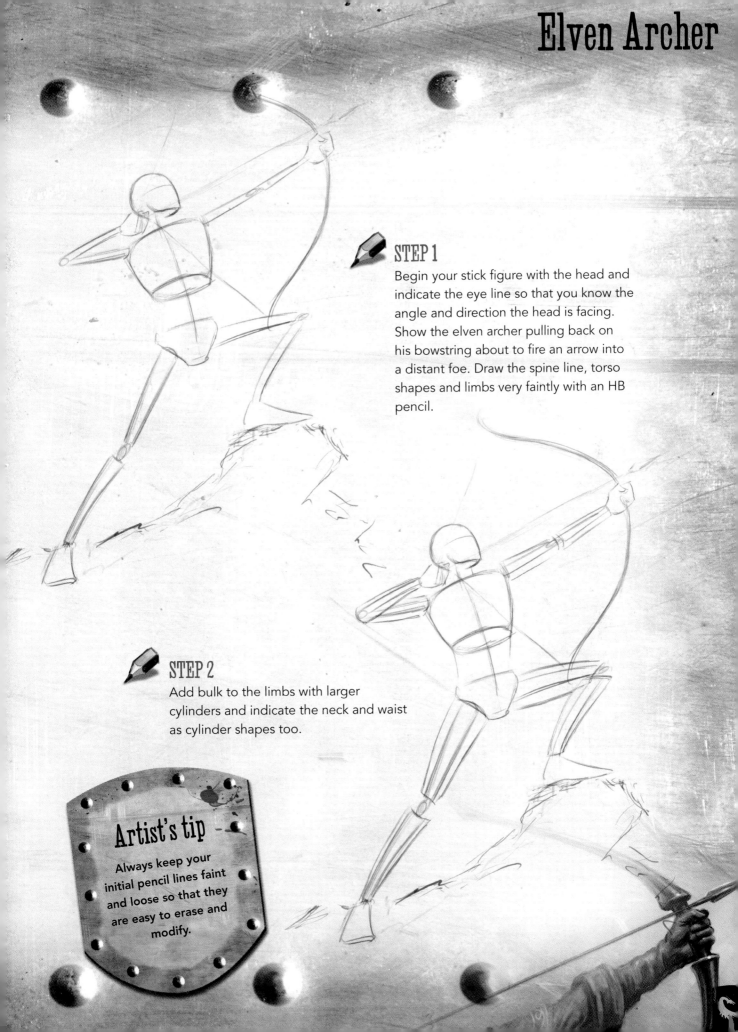

STEP 1

Begin your stick figure with the head and indicate the eye line so that you know the angle and direction the head is facing. Show the elven archer pulling back on his bowstring about to fire an arrow into a distant foe. Draw the spine line, torso shapes and limbs very faintly with an HB pencil.

STEP 2

Add bulk to the limbs with larger cylinders and indicate the neck and waist as cylinder shapes too.

Artist's tip

Always keep your initial pencil lines faint and loose so that they are easy to erase and modify.

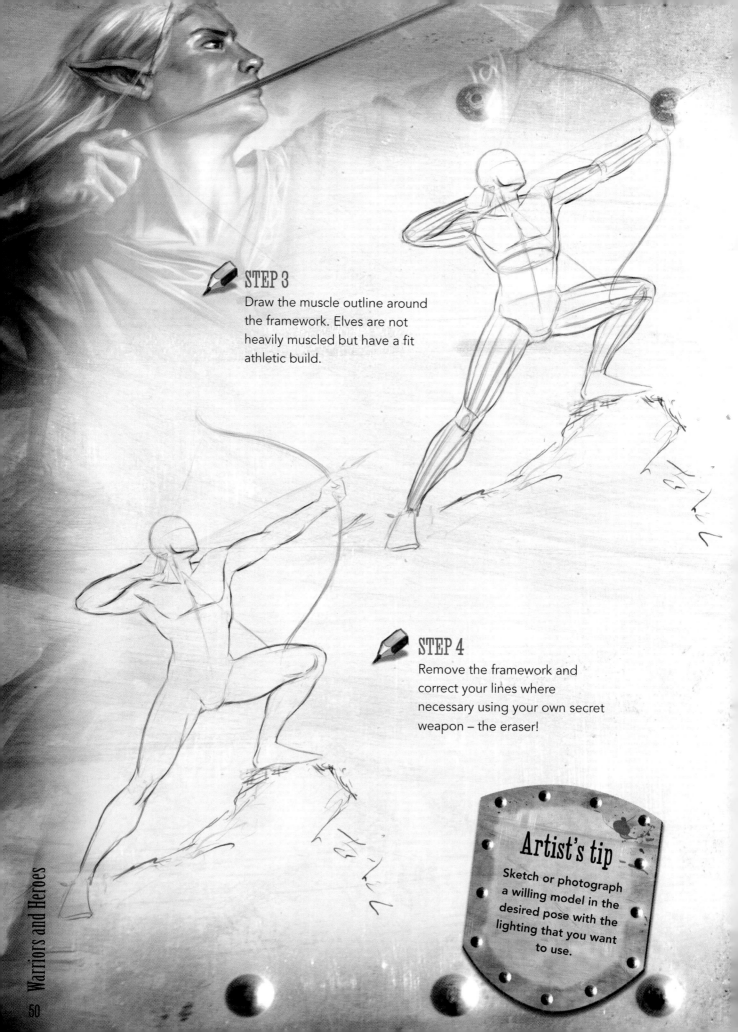

STEP 3

Draw the muscle outline around the framework. Elves are not heavily muscled but have a fit athletic build.

STEP 4

Remove the framework and correct your lines where necessary using your own secret weapon – the eraser!

Artist's tip

Sketch or photograph a willing model in the desired pose with the lighting that you want to use.

STEP 5

Draw the head, feet and hands in detail and give him pointed elven ears. Although he will be fully dressed it's a good idea to draw the muscle shapes in more detail as this can affect the way the folds fall. The amount of detail you want to indicate is up to you.

STEP 6

With the outline and pose established start to dress the figure. Elven archers rely on stealth and manoeuvrability to defeat their enemies so they do not wear any heavy armour. Dress your elf in a light cloth tunic and leggings with leather boots and long leather gloves. Don't forget the quiver to store those lethal arrows.

A belt with intricate elven style patterns adds visual interest.

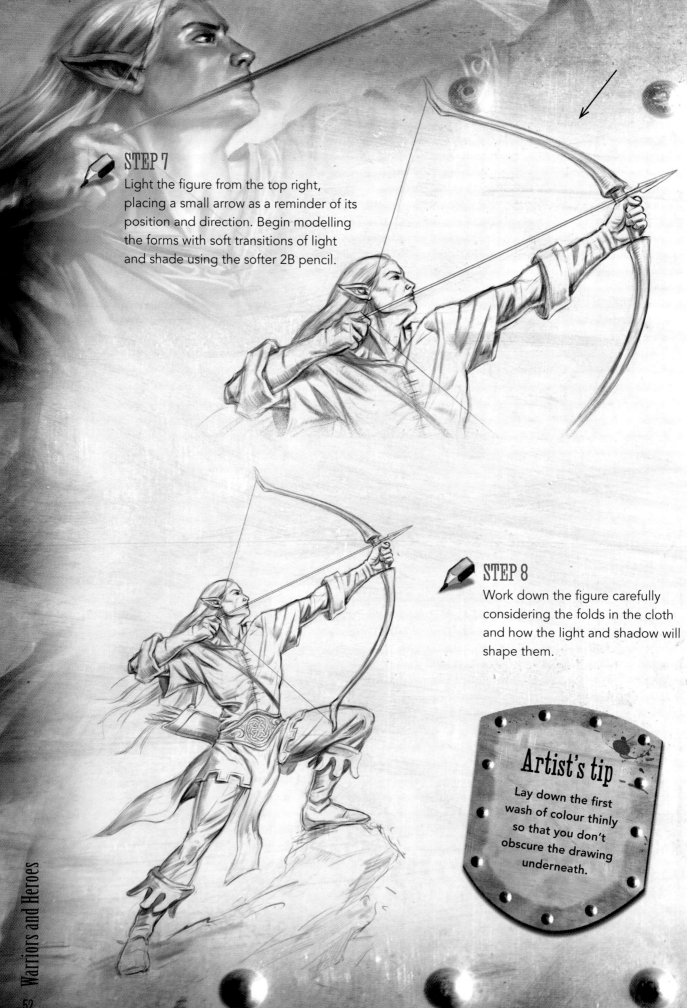

STEP 7

Light the figure from the top right, placing a small arrow as a reminder of its position and direction. Begin modelling the forms with soft transitions of light and shade using the softer 2B pencil.

STEP 8

Work down the figure carefully considering the folds in the cloth and how the light and shadow will shape them.

Artist's tip

Lay down the first wash of colour thinly so that you don't obscure the drawing underneath.

Elven Archer

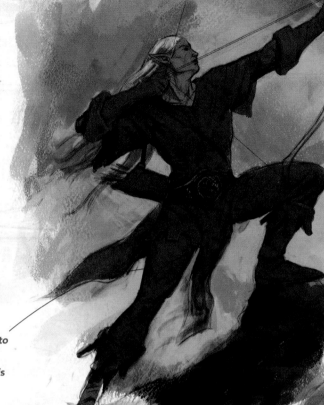

STEP 9

Given the nature of the elven archer's surroundings, a green colour scheme seems the most obvious choice. As you block in colours feel free to modify or improve elements as they suggest themselves, for example modifying the sleeves to be more loose and flowing. It's important not to feel too restricted when creating art, but it's much easier to make changes during the earlier stages of a painting than later on.

Dark olive tones for his clothing will help to conceal him in his wooded homeland and allow him to spring a surprise attack on his enemies.

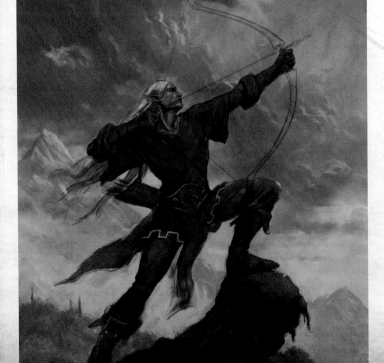

STEP 10

Add a suitable landscape with mountains and woodland as a background, and very roughly indicate the light and shadow on the figure to provide a base to work on.

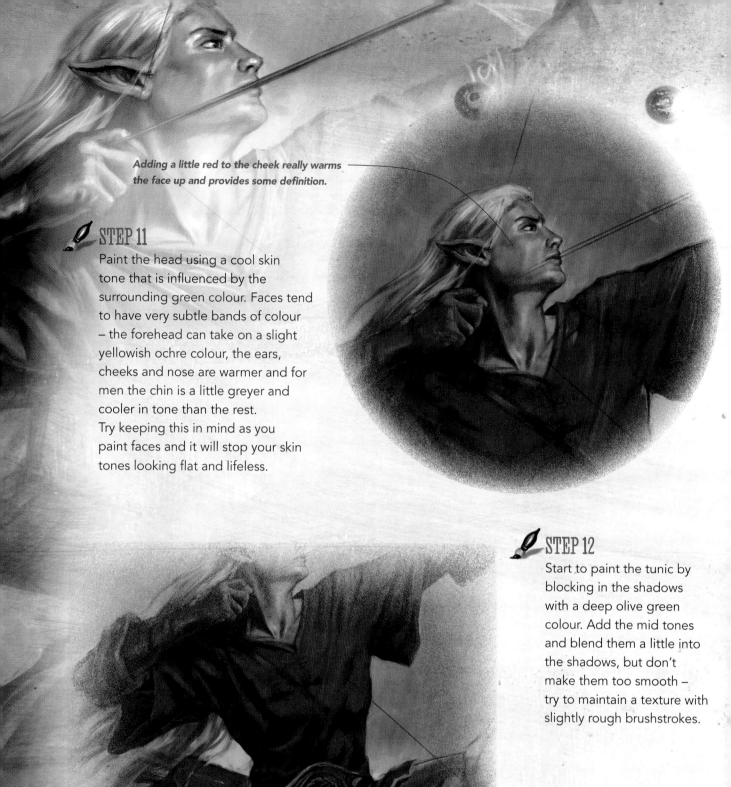

Adding a little red to the cheek really warms the face up and provides some definition.

STEP 11

Paint the head using a cool skin tone that is influenced by the surrounding green colour. Faces tend to have very subtle bands of colour – the forehead can take on a slight yellowish ochre colour, the ears, cheeks and nose are warmer and for men the chin is a little greyer and cooler in tone than the rest. Try keeping this in mind as you paint faces and it will stop your skin tones looking flat and lifeless.

STEP 12

Start to paint the tunic by blocking in the shadows with a deep olive green colour. Add the mid tones and blend them a little into the shadows, but don't make them too smooth – try to maintain a texture with slightly rough brushstrokes.

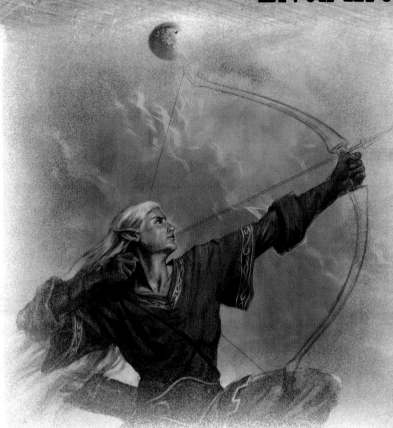

 STEP 13

Continue the tunic by adding highlights, keeping them subtle and not too bright or it will make the cloth look shiny. Use a very fine brush to paint some suitable elven patterns around the sleeves and collar with a very light green colour. Give these slight highlights where necessary by painting on top with an even lighter almost white colour. Block in the belt with a dark brown and then carefully add the pattern on top in the same way.

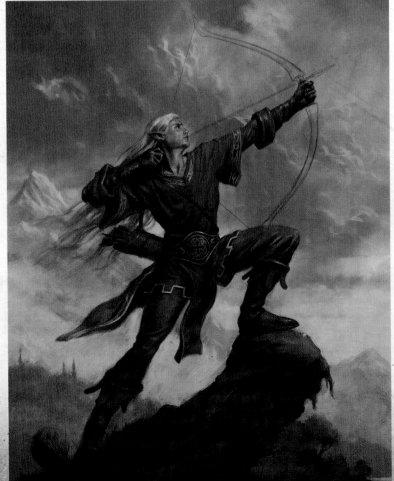

STEP 14

Move on and paint the leggings using the same method as the tunic. The leather boots, gloves and quiver are painted in the same way as the cloth but are blended a little more smoothly, and because leather is shinier and more reflective the highlights are much sharper and brighter.

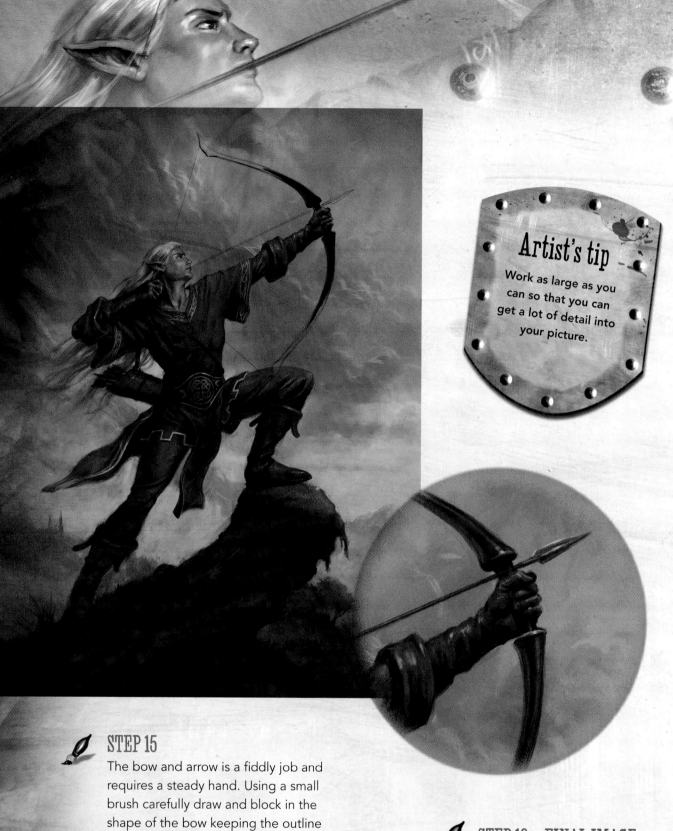

STEP 15

The bow and arrow is a fiddly job and requires a steady hand. Using a small brush carefully draw and block in the shape of the bow keeping the outline clean and smooth.

STEP 16 – FINAL IMAGE

Finish the bow by adding sharp bright highlights and finally draw the bowstring and arrow with a dark colour keeping the lines very straight.

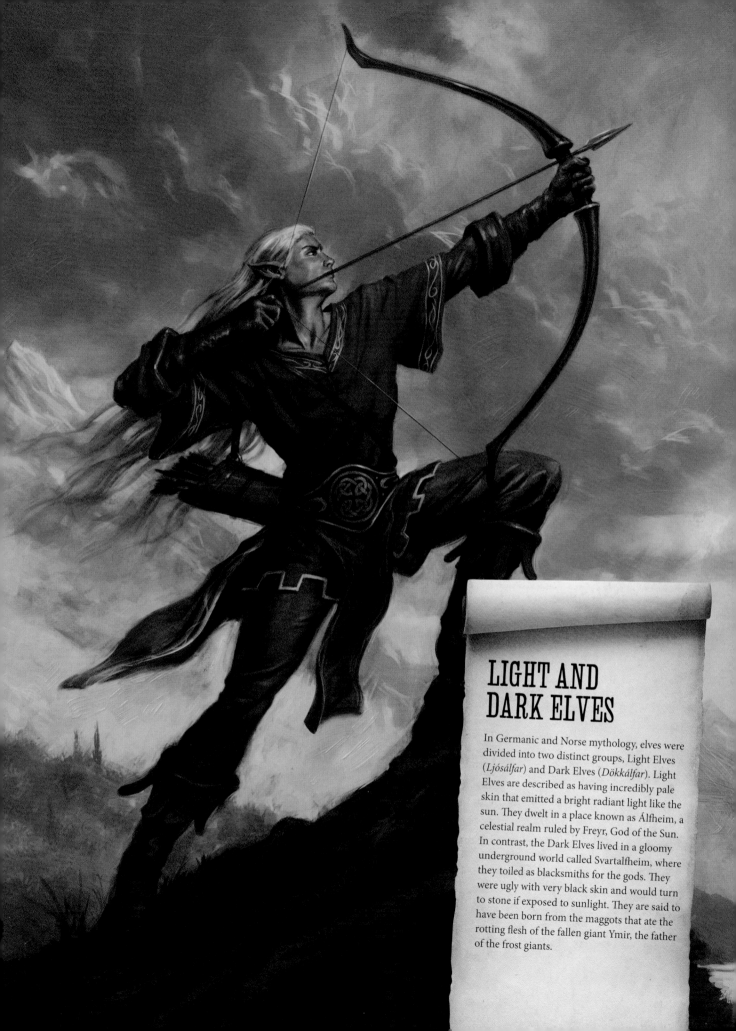

LIGHT AND DARK ELVES

In Germanic and Norse mythology, elves were divided into two distinct groups, Light Elves (*Ljósálfar*) and Dark Elves (*Dökkálfar*). Light Elves are described as having incredibly pale skin that emitted a bright radiant light like the sun. They dwelt in a place known as Álfheim, a celestial realm ruled by Freyr, God of the Sun. In contrast, the Dark Elves lived in a gloomy underground world called Svartalfheim, where they toiled as blacksmiths for the gods. They were ugly with very black skin and would turn to stone if exposed to sunlight. They are said to have been born from the maggots that ate the rotting flesh of the fallen giant Ymir, the father of the frost giants.

Samurai

A Samurai was a member of the Japanese military nobility; he gave his life in servitude to his master and lived by a strict code of conduct, called Bushido — The Way of the Warrior. This code demanded loyalty, respect and self-discipline. Samurai were well-educated and bore influence on Japanese culture, and tales of their exploits have legendary status. A Samurai sword, or Katana, is considered the very soul of the Samurai. With its curved single edge blade and long grip, it's renowned for its sharpness. The warriors dressed in armour and would sometimes wear facemasks that gave them a frightening theatrical aspect. In the face of defeat they would kill themselves to prevent the shame of a dishonourable death being passed on to their descendants.

'The truth is that strength lies in the interior of the warrior:
in his heart, his mind and his spirit'

Miyamoto Musashi

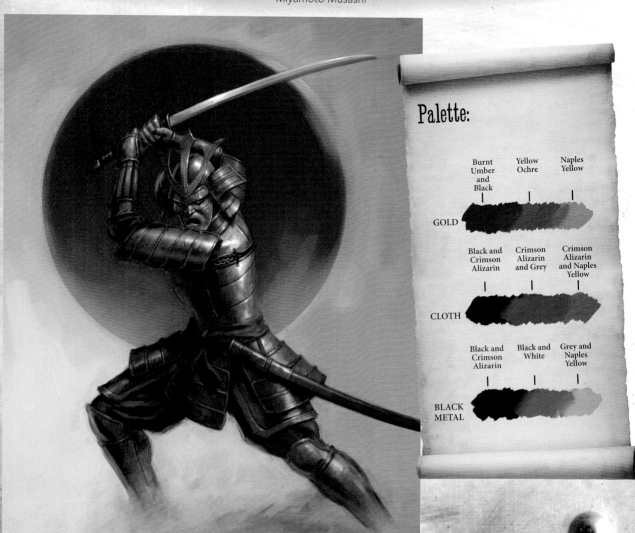

Palette:

GOLD	Burnt Umber and Black	Yellow Ochre	Naples Yellow

CLOTH	Black and Crimson Alizarin	Crimson Alizarin and Grey	Crimson Alizarin and Naples Yellow

BLACK METAL	Black and Crimson Alizarin	Black and White	Grey and Naples Yellow

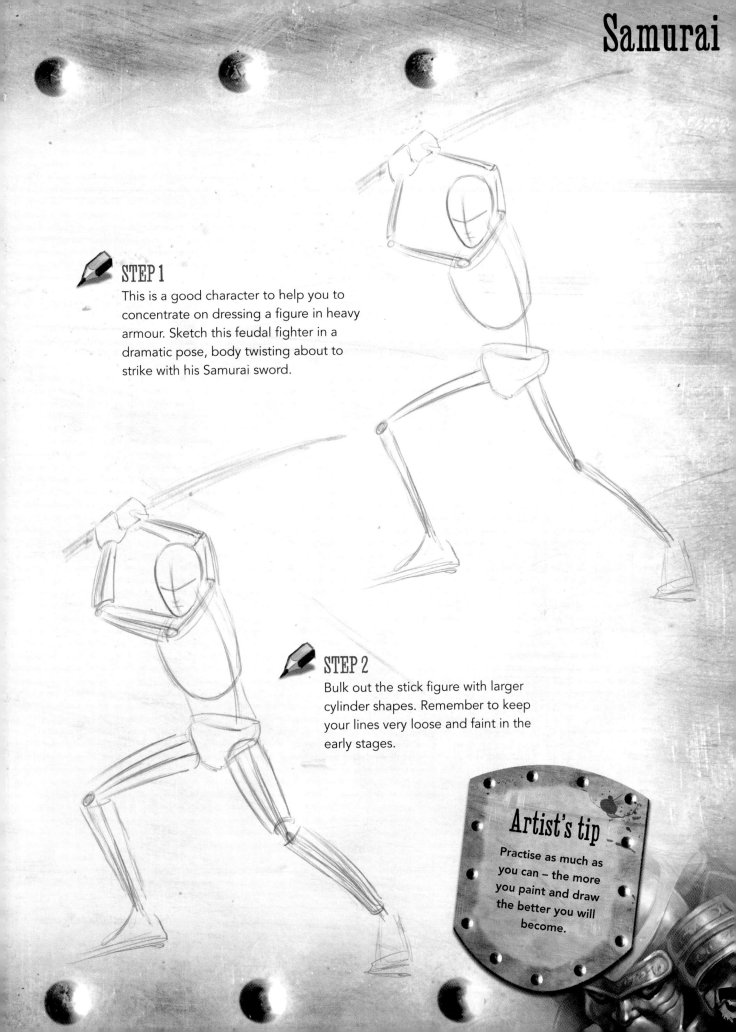

STEP 1

This is a good character to help you to concentrate on dressing a figure in heavy armour. Sketch this feudal fighter in a dramatic pose, body twisting about to strike with his Samurai sword.

STEP 2

Bulk out the stick figure with larger cylinder shapes. Remember to keep your lines very loose and faint in the early stages.

Artist's tip

Practise as much as you can – the more you paint and draw the better you will become.

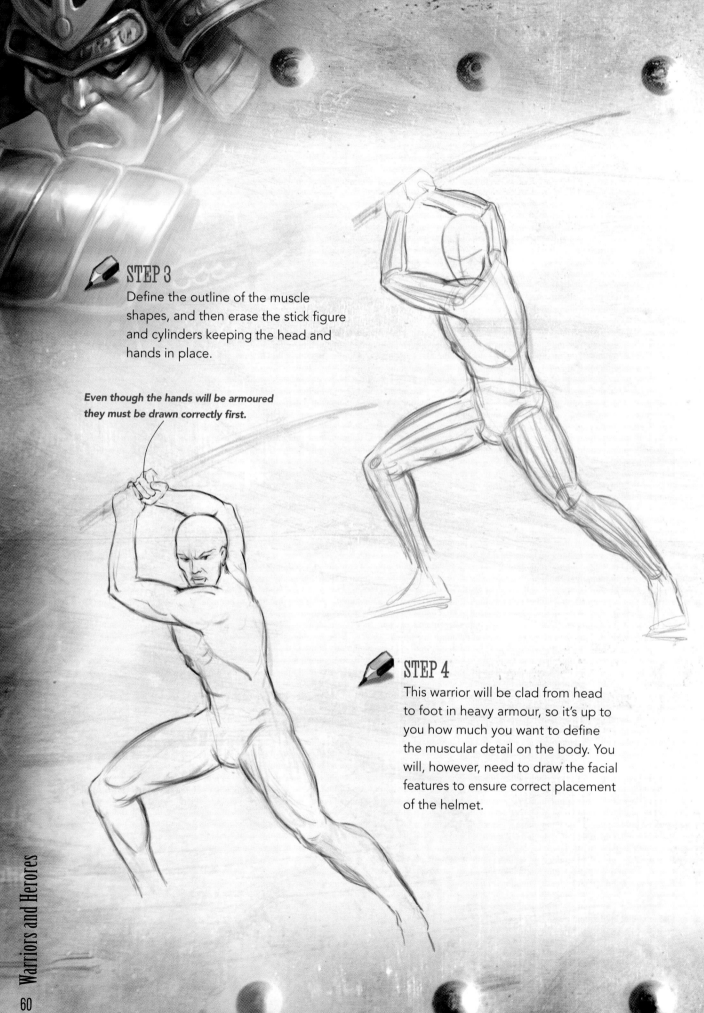

STEP 3

Define the outline of the muscle shapes, and then erase the stick figure and cylinders keeping the head and hands in place.

Even though the hands will be armoured they must be drawn correctly first.

STEP 4

This warrior will be clad from head to foot in heavy armour, so it's up to you how much you want to define the muscular detail on the body. You will, however, need to draw the facial features to ensure correct placement of the helmet.

Samurai

STEP 5

Study images of Samurai armour, which is quite complex, and keep any reference to hand as you draw. Samurai helmets sometimes had a mask to protect the face, often with a frightening expression to scare the life out of their enemies. Carefully indicate, very faintly at first, the outlines of the helmet over the head drawing. When you are happy with it, strengthen the lines and remove the head drawing with the eraser. Do the same with the arms, faintly at first then confirming with stronger lines and erasing.

STEP 6

Continue dressing the rest of the figure, wrapping the armour plates around the initial drawing, always following the flow and curvature of the body shapes they cover. Rub out the unwanted lines and draw the curved Samurai sword.

Make sure that the scabbard has a similar curved shape to the sword.

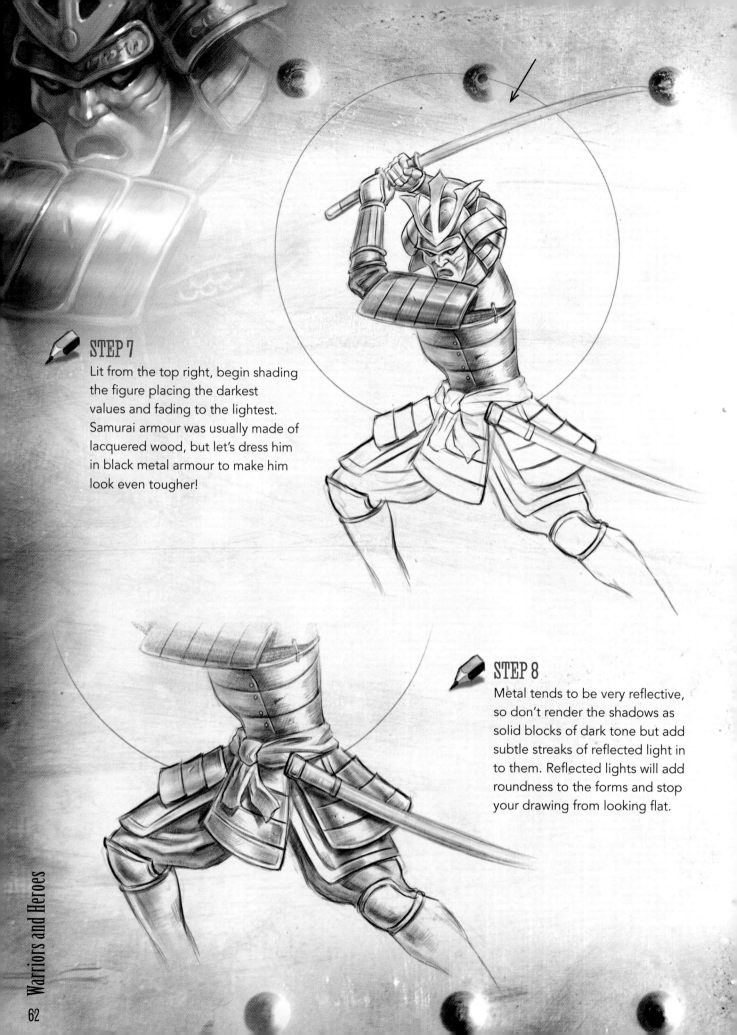

STEP 7

Lit from the top right, begin shading the figure placing the darkest values and fading to the lightest. Samurai armour was usually made of lacquered wood, but let's dress him in black metal armour to make him look even tougher!

STEP 8

Metal tends to be very reflective, so don't render the shadows as solid blocks of dark tone but add subtle streaks of reflected light in to them. Reflected lights will add roundness to the forms and stop your drawing from looking flat.

STEP 9

Loosely wash in flat colours choosing a dark blue-grey for the armour with gold trimmings to break it up, and use a deep purple for the under garment and cloth around his waist.

STEP 10

Roughly add light and shade to give volume to the flat painting – this will make it easier to bring each part to a finish as you will have solved most of the lighting problems.

Artist's tip

Brushstrokes are your friend: they can convey movement, texture and add vitality to an image.

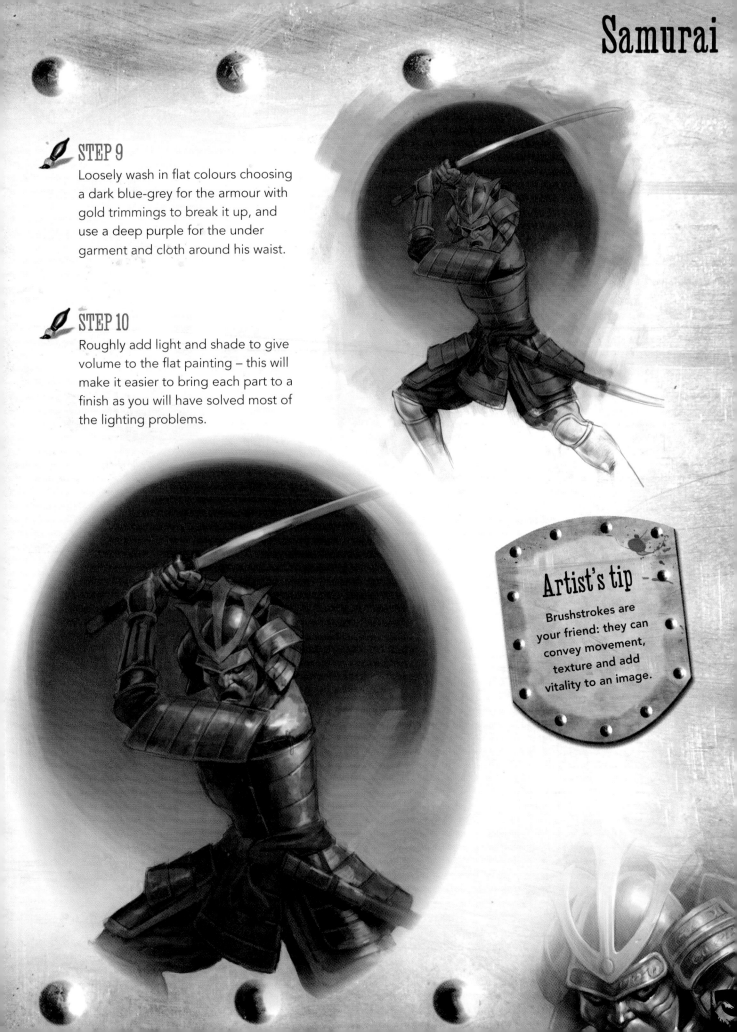

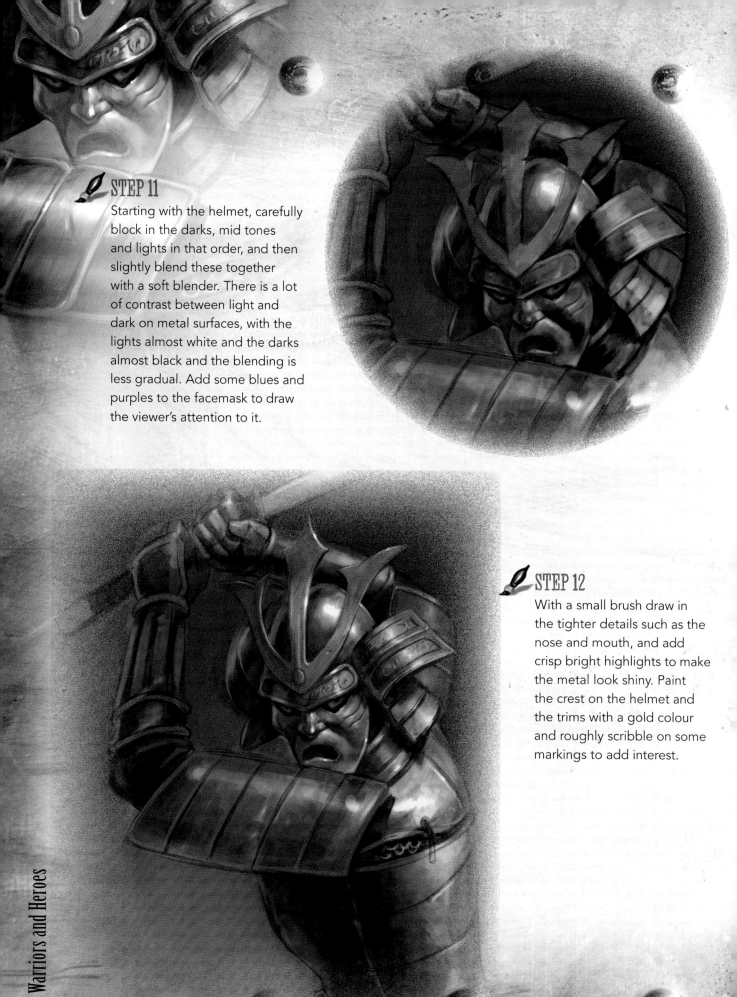

STEP 11

Starting with the helmet, carefully block in the darks, mid tones and lights in that order, and then slightly blend these together with a soft blender. There is a lot of contrast between light and dark on metal surfaces, with the lights almost white and the darks almost black and the blending is less gradual. Add some blues and purples to the facemask to draw the viewer's attention to it.

STEP 12

With a small brush draw in the tighter details such as the nose and mouth, and add crisp bright highlights to make the metal look shiny. Paint the crest on the helmet and the trims with a gold colour and roughly scribble on some markings to add interest.

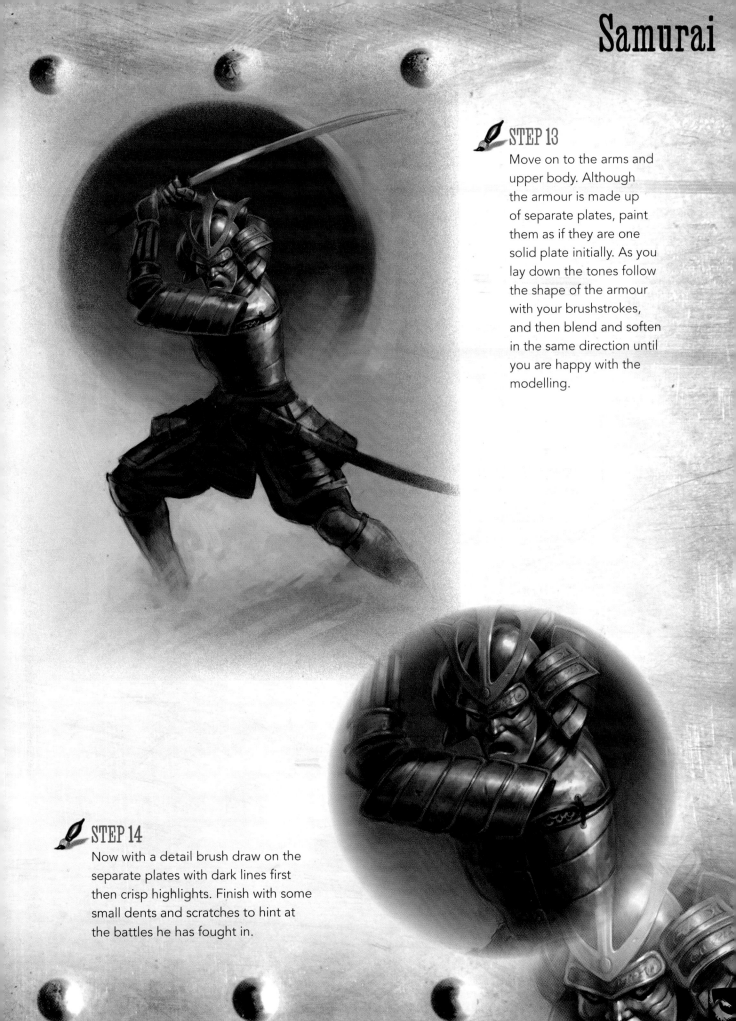

STEP 13

Move on to the arms and upper body. Although the armour is made up of separate plates, paint them as if they are one solid plate initially. As you lay down the tones follow the shape of the armour with your brushstrokes, and then blend and soften in the same direction until you are happy with the modelling.

STEP 14

Now with a detail brush draw on the separate plates with dark lines first then crisp highlights. Finish with some small dents and scratches to hint at the battles he has fought in.

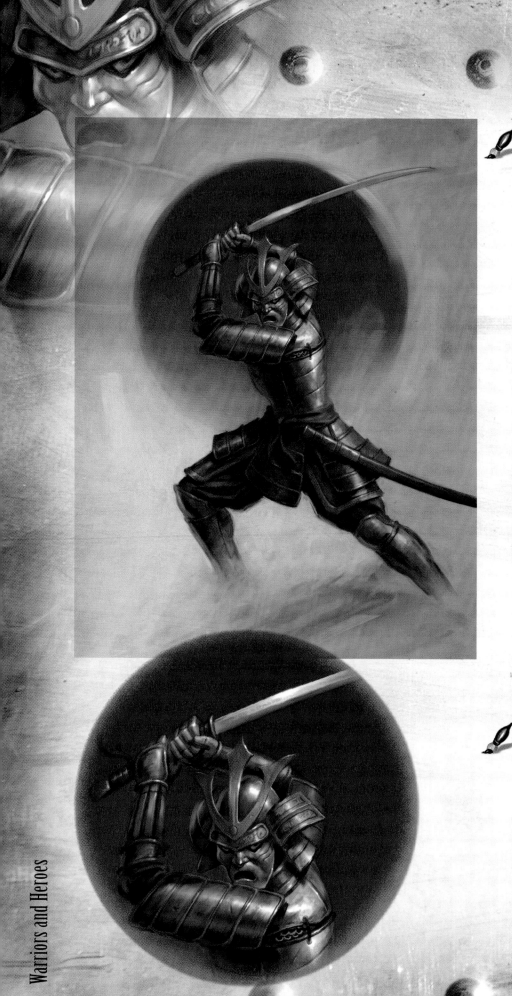

STEP 15

Continue painting the rest of the armour in the same way, as larger single plates, blending the tones then separating them into smaller plates with a detail brush. Don't blend too much or it will make the metal look too new and almost like plastic, leave a little brushwork to add some character to the surfaces.

Artist's tip

Keep your brushes ready for action by making sure you clean them after every painting session.

STEP 16 – FINAL IMAGE

Paint him a sword to be proud of by carefully drawing over the outlines with a detail brush, retaining the subtle curve of the blade, then fill in with colour and finish off with bright highlights.

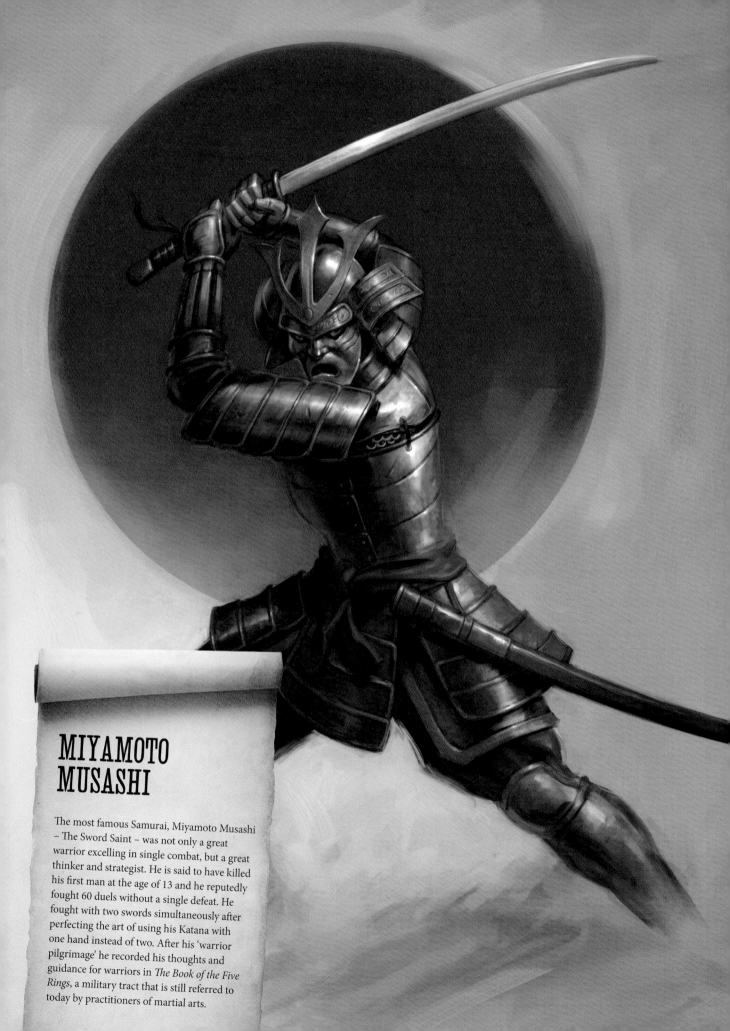

MIYAMOTO MUSASHI

The most famous Samurai, Miyamoto Musashi – The Sword Saint – was not only a great warrior excelling in single combat, but a great thinker and strategist. He is said to have killed his first man at the age of 13 and he reputedly fought 60 duels without a single defeat. He fought with two swords simultaneously after perfecting the art of using his Katana with one hand instead of two. After his 'warrior pilgrimage' he recorded his thoughts and guidance for warriors in *The Book of the Five Rings*, a military tract that is still referred to today by practitioners of martial arts.

Amazon

Descendents of Ares, the God of War, these ferocious female warriors formed an independent kingdom, free of patriarchal rule. Female children were taught the art of warfare from an early age and became expert warriors both on horseback and as foot soldiers. The strength, courage and skill of the Amazons matched or exceeded that of any male counterpart, and the Ancient Greeks considered them as worthy opponents who presented a real threat to the natural order. Many brutal wars were fought between the two and are collectively called Amazonomachy.

> 'These fierce women... more ready to wield sword and spear than distaff or needle.'
>
> Manual of Mythology *by A.S. Murray, 1873*

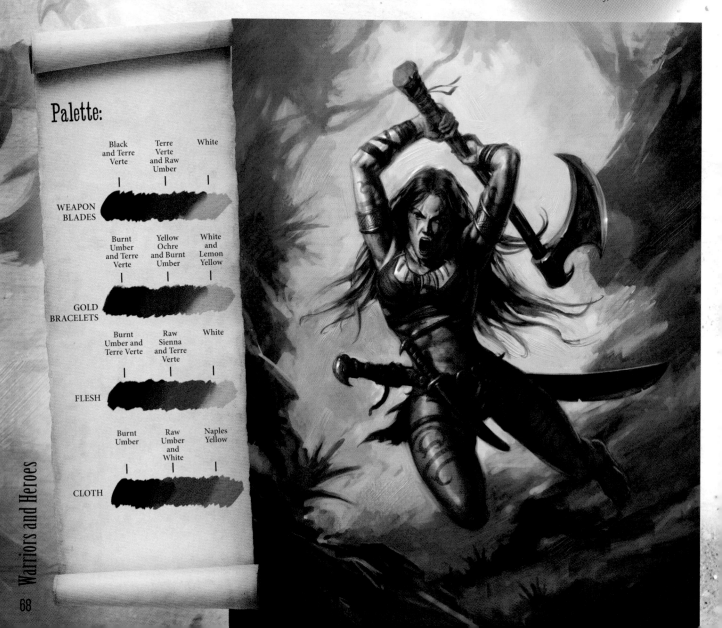

Palette:

WEAPON BLADES
- Black and Terre Verte
- Terre Verte and Raw Umber
- White

GOLD BRACELETS
- Burnt Umber and Terre Verte
- Yellow Ochre and Burnt Umber
- White and Lemon Yellow

FLESH
- Burnt Umber and Terre Verte
- Raw Sienna and Terre Verte
- White

CLOTH
- Burnt Umber
- Raw Umber and White
- Naples Yellow

Warriors and Heroes

 ## STEP 1

Let's start pushing the stick figure into more dynamic poses and introduce action and foreshortening. Sketch this fearsome female jumping towards us, swinging a giant axe. Her arms are above her head with her forearms and left leg moving away from us. Her right leg is lifted up pointing towards us. Imagine your cylinders in these positions and place small lines around the foreshortened tubes to help define their shape and direction. With foreshortening you are trying to create a three dimensional reality on the flat surface of the canvas.

 ## STEP 2

Draw larger cylinders around the limbs, foreshortened and in the proper perspective.

Artist's tip

Always carry a sketchbook with you to quickly jot down any interesting ideas or inspiration as they come to you.

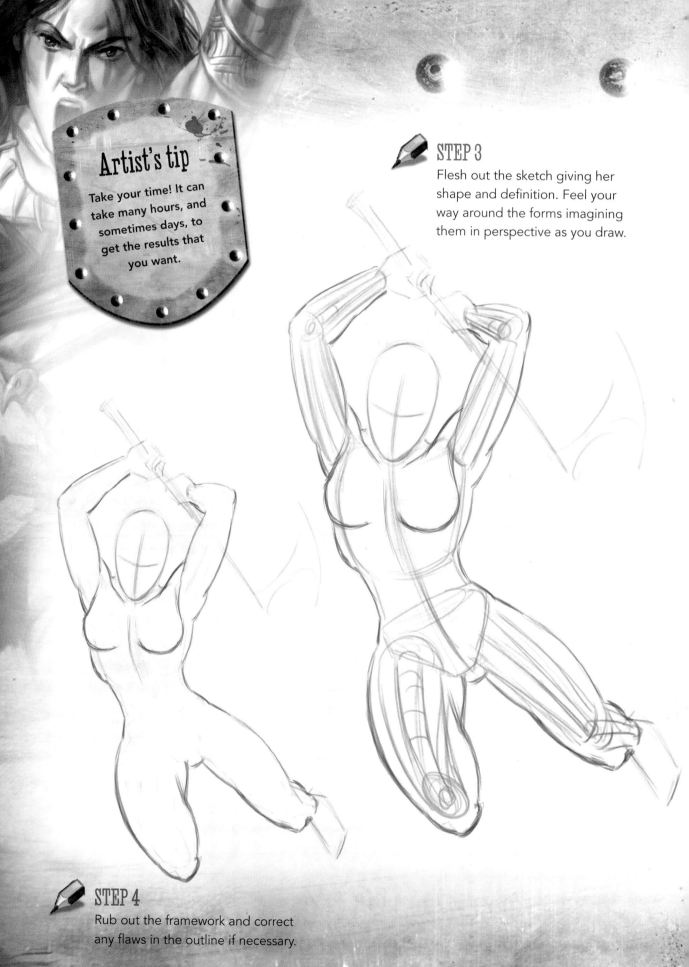

STEP 3

Flesh out the sketch giving her shape and definition. Feel your way around the forms imagining them in perspective as you draw.

STEP 4

Rub out the framework and correct any flaws in the outline if necessary.

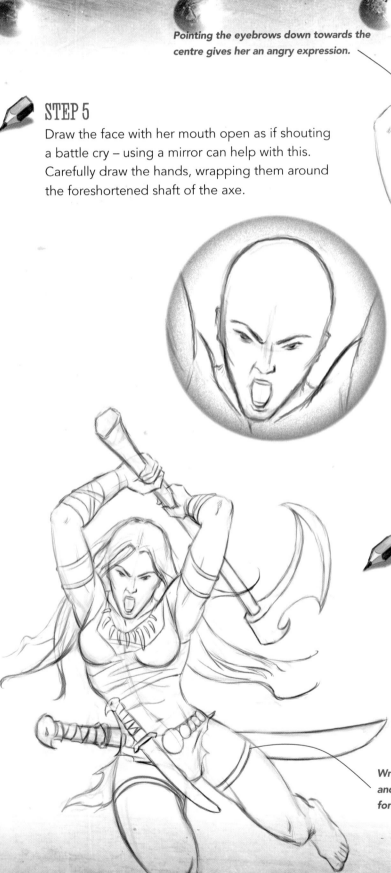

Pointing the eyebrows down towards the centre gives her an angry expression.

STEP 5

Draw the face with her mouth open as if shouting a battle cry – using a mirror can help with this. Carefully draw the hands, wrapping them around the foreshortened shaft of the axe.

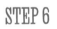

STEP 6

Dress her in basic torn cloth and give her a necklace made from the teeth of hunted animals, or the finger bones from her victims! Draw the axe in perspective, with the shaft narrowing as it nears the axe head and attach a giant curved sword and dagger to her belt.

Wrapping straps or bands around her arms and legs is a good device to further show the foreshortening of the limbs.

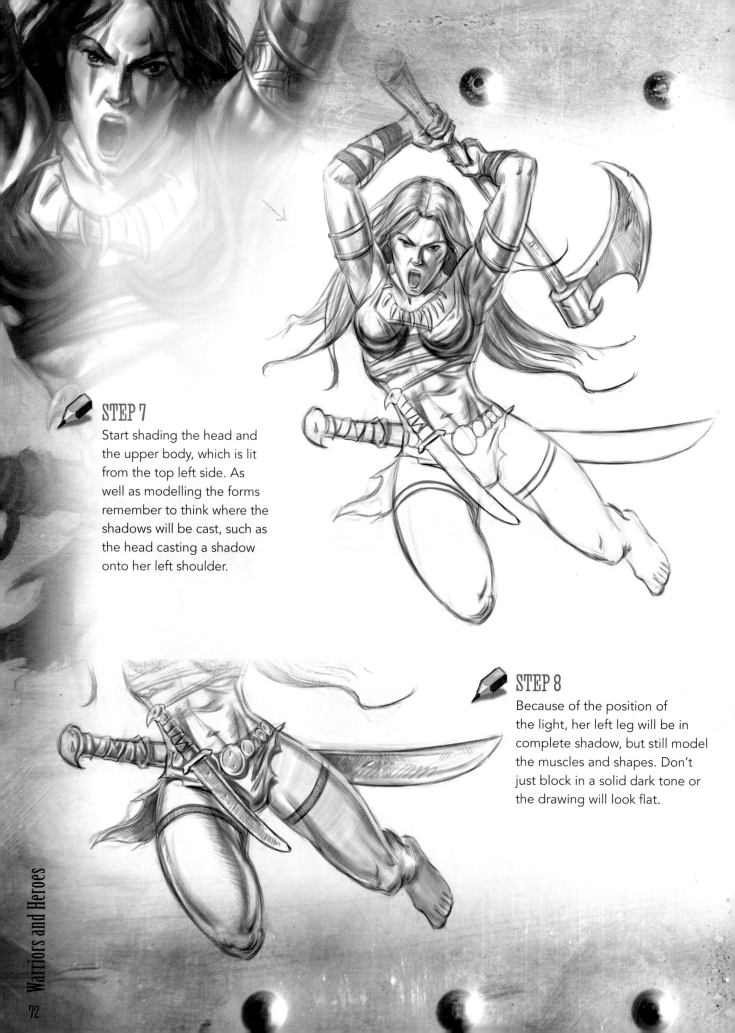

STEP 7

Start shading the head and the upper body, which is lit from the top left side. As well as modelling the forms remember to think where the shadows will be cast, such as the head casting a shadow onto her left shoulder.

STEP 8

Because of the position of the light, her left leg will be in complete shadow, but still model the muscles and shapes. Don't just block in a solid dark tone or the drawing will look flat.

Lots of lively brush work in the background adds movement to the image.

 STEP 9
Choose a blue-green colour scheme and remember that these colours will influence all other colours in the picture.

 STEP 10
Roughly wash shadows and light over the under painting, not worrying about the finish at this stage – you are just providing a solid base on which to build.

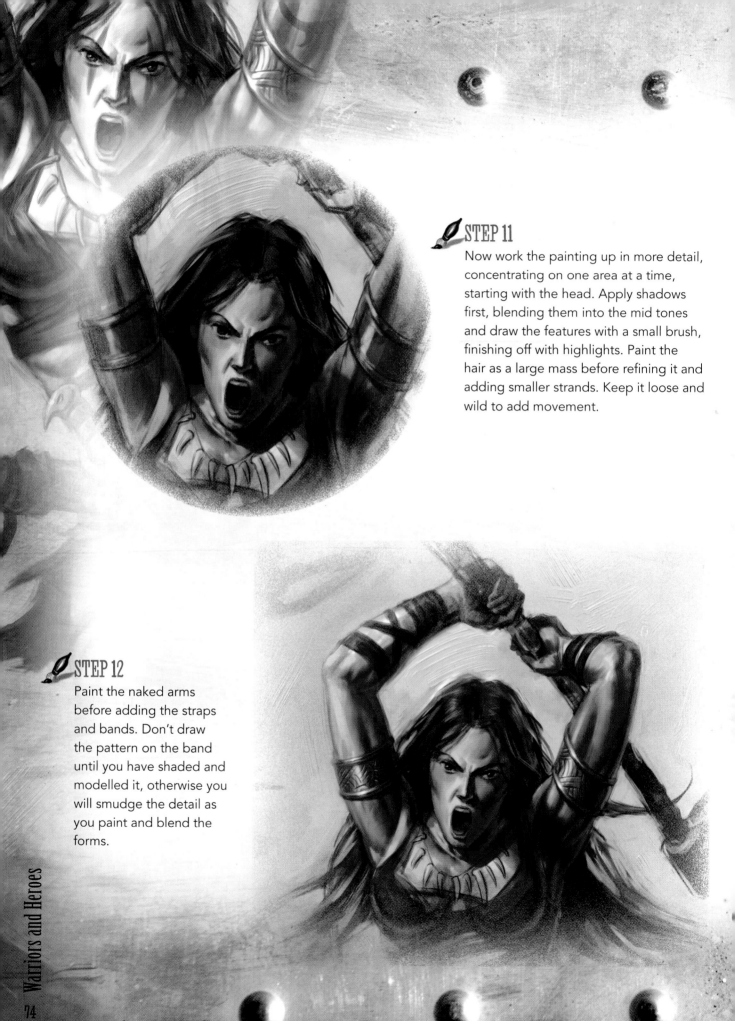

STEP 11

Now work the painting up in more detail, concentrating on one area at a time, starting with the head. Apply shadows first, blending them into the mid tones and draw the features with a small brush, finishing off with highlights. Paint the hair as a large mass before refining it and adding smaller strands. Keep it loose and wild to add movement.

STEP 12

Paint the naked arms before adding the straps and bands. Don't draw the pattern on the band until you have shaded and modelled it, otherwise you will smudge the detail as you paint and blend the forms.

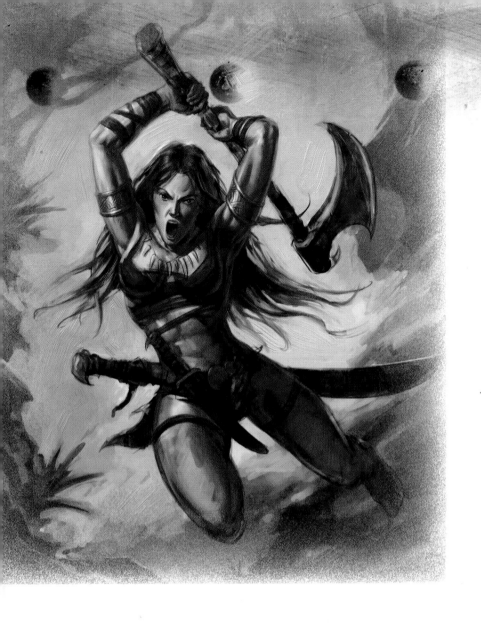

 STEP 13

Do the same with the torso; paint the naked exposed parts of the body first, modelling the muscles and forms correctly and, when you are happy with the body, tackle the cloth and necklace.

STEP 14

Move down to the legs laying in dark washes first. Her right leg is coming towards us and will catch a lot of light, so block in the mid tones next to the darks and place a bright, curved highlight along the thigh and soften with a blender. The other leg is much darker and, as it gets further away, add some of the background colour into the shadows to help give the impression of depth.

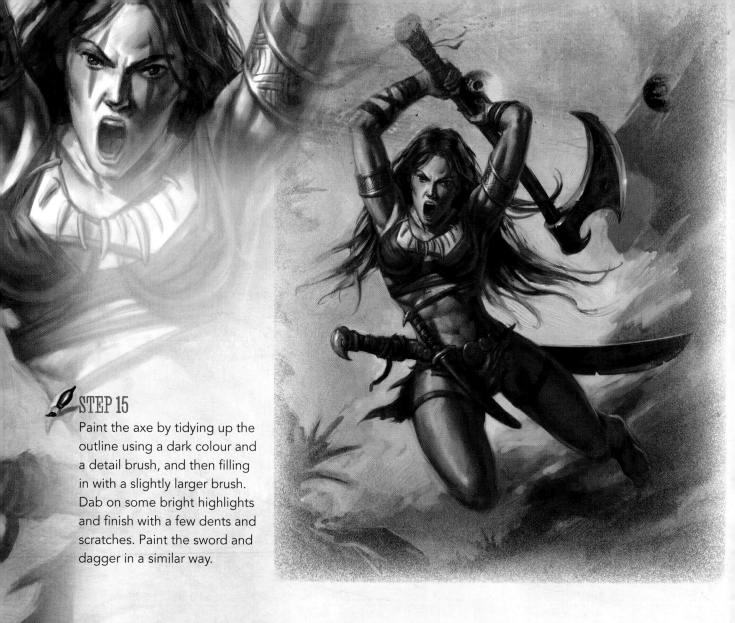

 ## STEP 15

Paint the axe by tidying up the outline using a dark colour and a detail brush, and then filling in with a slightly larger brush. Dab on some bright highlights and finish with a few dents and scratches. Paint the sword and dagger in a similar way.

 ## STEP 16 – FINAL IMAGE

Finish by carefully painting some tattoos on her body with a detail brush. Follow the curvature of the forms as you draw them and shade them the same as the flesh underneath so that they do not look stuck on. This will make her look more aggressive and enforce the wild nature of this lethal lady.

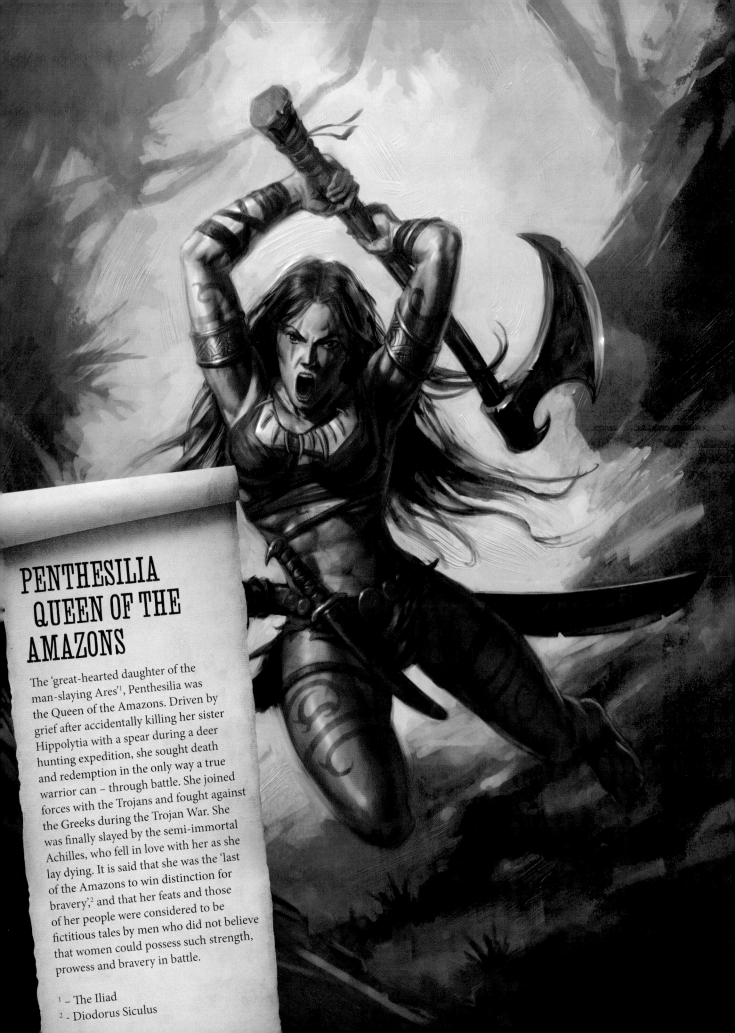

PENTHESILIA QUEEN OF THE AMAZONS

The 'great-hearted daughter of the man-slaying Ares'[1], Penthesilia was the Queen of the Amazons. Driven by grief after accidentally killing her sister Hippolytia with a spear during a deer hunting expedition, she sought death and redemption in the only way a true warrior can – through battle. She joined forces with the Trojans and fought against the Greeks during the Trojan War. She was finally slayed by the semi-immortal Achilles, who fell in love with her as she lay dying. It is said that she was the 'last of the Amazons to win distinction for bravery'[2] and that her feats and those of her people were considered to be fictitious tales by men who did not believe that women could possess such strength, prowess and bravery in battle.

[1] – The Iliad
[2] - Diodorus Siculus

Achilles

This powerful Greek hero, semi-immortal with a raging temper, is presented as the greatest warrior of the Trojan War in Homer's Iliad. Born of the nymph Thetis and King Peleus, his early death was foretold and so, as a baby, his mother dipped him in the sacred river Styx to make him immortal. However, she held on to his heel, leaving a vulnerable spot, untouched by the water. He was brought up by the centaur, Cheiron, who fed him on the hearts of lions and the marrow of bears and instructed him in the art of warfare. At the age of fifteen he went off to fight in the Trojan War where he captured 23 towns in Trojan territory and killed many Trojan allies including the Amazon Warrior, Penthesilia. He remained undefeated until he was shot with a poisoned arrow in the heel, the one part of his body that was mortal. He died from the wound and after his death his armour was fought after as a prize for bravery.

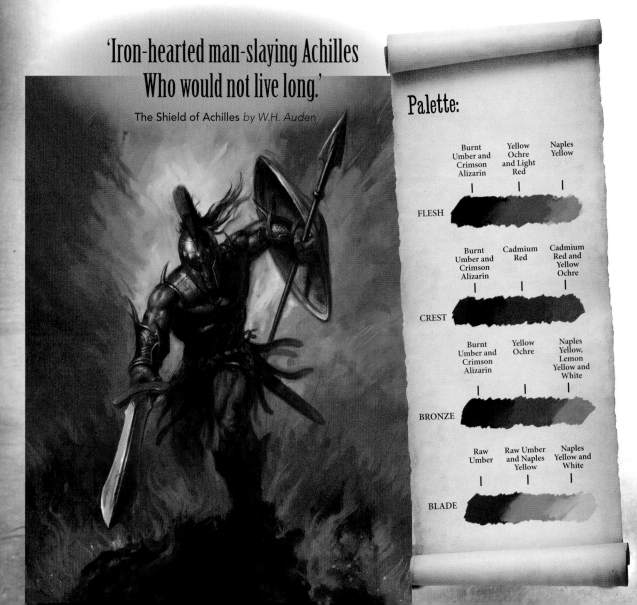

'Iron-hearted man-slaying Achilles
Who would not live long.'

The Shield of Achilles *by W.H. Auden*

Palette:

FLESH
- Burnt Umber and Crimson Alizarin
- Yellow Ochre and Light Red
- Naples Yellow

CREST
- Burnt Umber and Crimson Alizarin
- Cadmium Red
- Cadmium Red and Yellow Ochre

BRONZE
- Burnt Umber and Crimson Alizarin
- Yellow Ochre
- Naples Yellow, Lemon Yellow and White

BLADE
- Raw Umber
- Raw Umber and Naples Yellow
- Naples Yellow and White

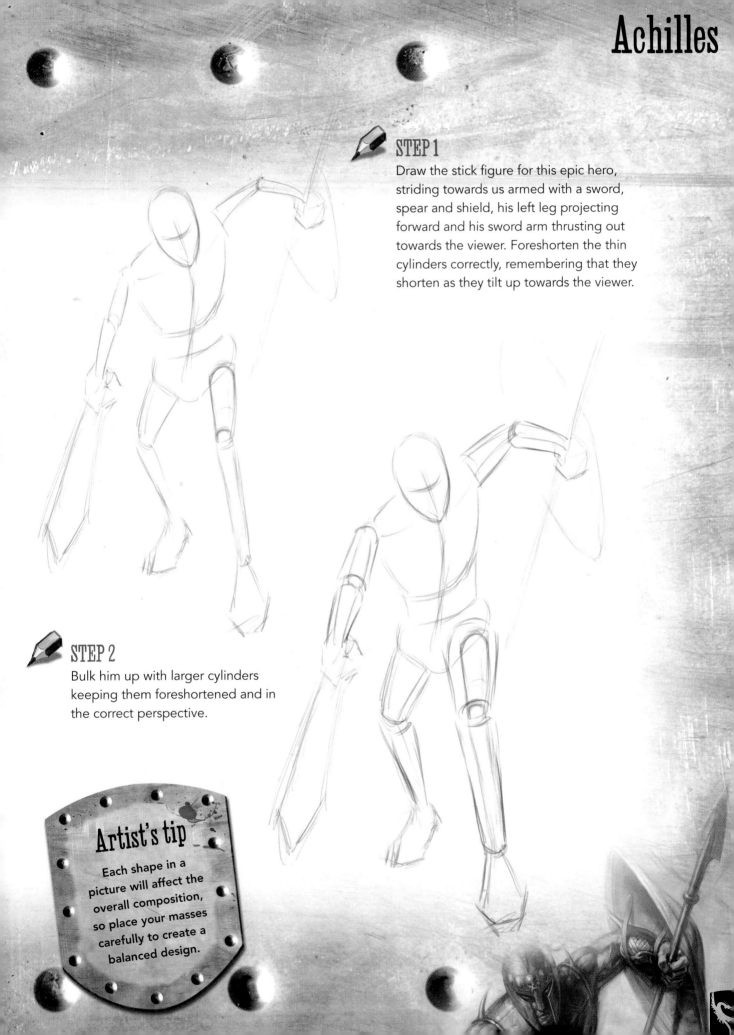

STEP 1

Draw the stick figure for this epic hero, striding towards us armed with a sword, spear and shield, his left leg projecting forward and his sword arm thrusting out towards the viewer. Foreshorten the thin cylinders correctly, remembering that they shorten as they tilt up towards the viewer.

STEP 2

Bulk him up with larger cylinders keeping them foreshortened and in the correct perspective.

Artist's tip

Each shape in a picture will affect the overall composition, so place your masses carefully to create a balanced design.

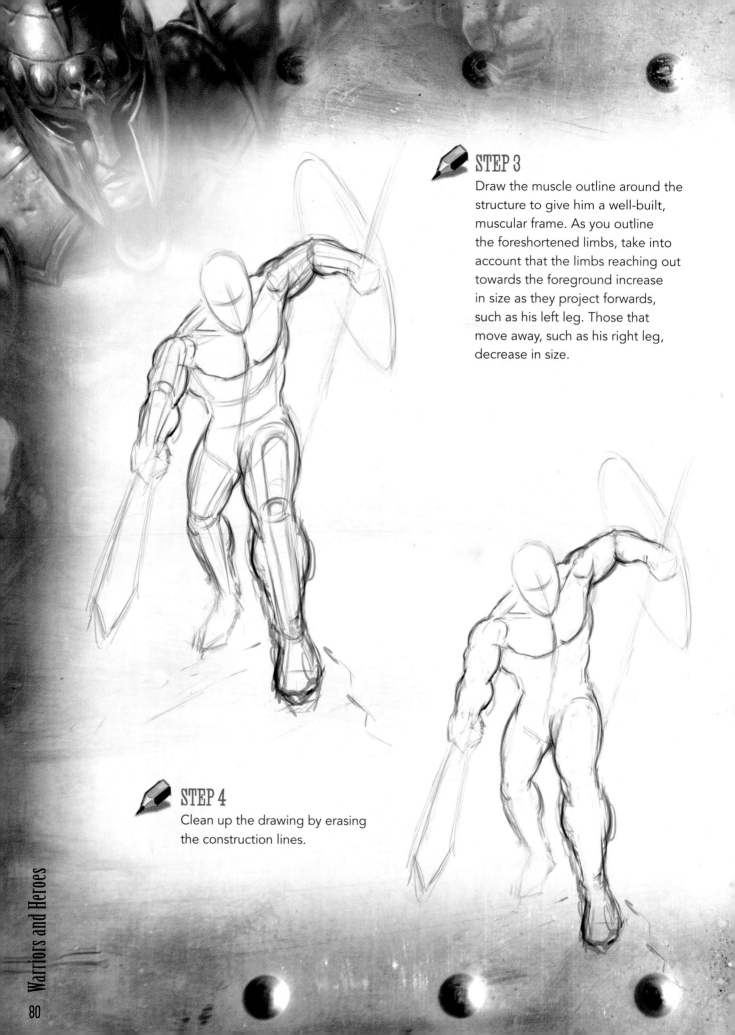

STEP 3

Draw the muscle outline around the structure to give him a well-built, muscular frame. As you outline the foreshortened limbs, take into account that the limbs reaching out towards the foreground increase in size as they project forwards, such as his left leg. Those that move away, such as his right leg, decrease in size.

STEP 4

Clean up the drawing by erasing the construction lines.

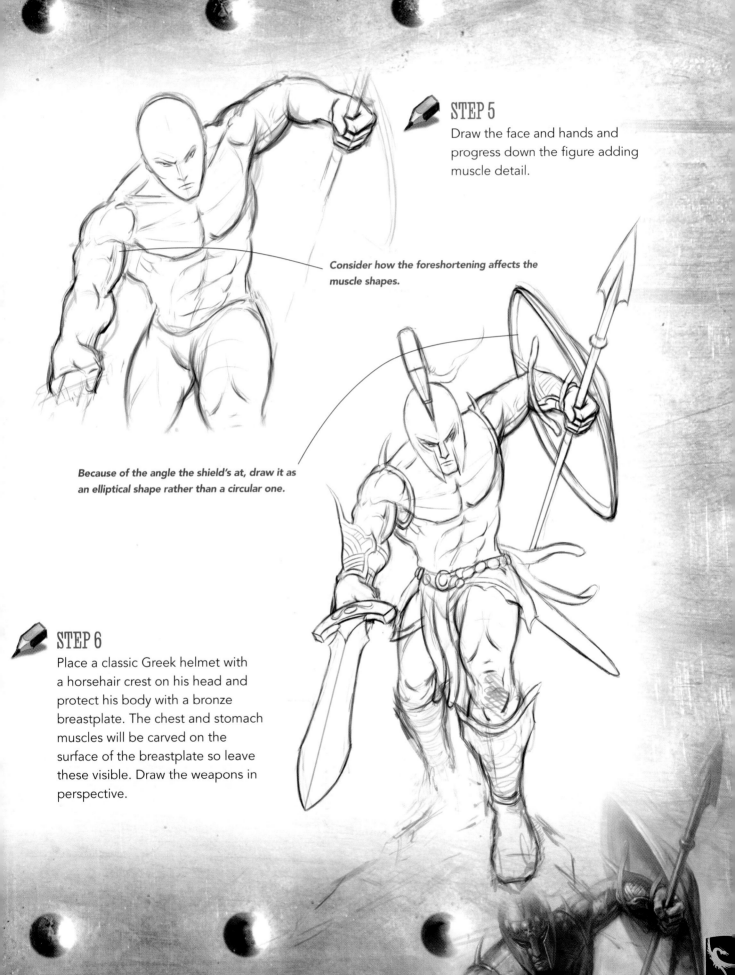

STEP 5

Draw the face and hands and progress down the figure adding muscle detail.

Consider how the foreshortening affects the muscle shapes.

Because of the angle the shield's at, draw it as an elliptical shape rather than a circular one.

STEP 6

Place a classic Greek helmet with a horsehair crest on his head and protect his body with a bronze breastplate. The chest and stomach muscles will be carved on the surface of the breastplate so leave these visible. Draw the weapons in perspective.

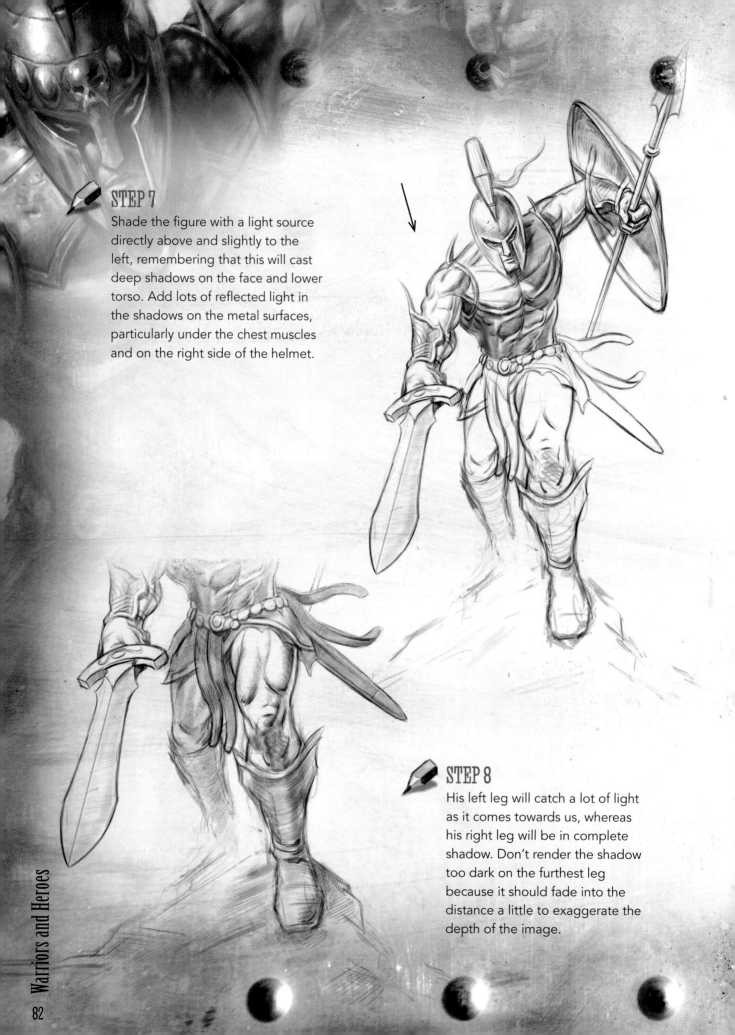

STEP 7

Shade the figure with a light source directly above and slightly to the left, remembering that this will cast deep shadows on the face and lower torso. Add lots of reflected light in the shadows on the metal surfaces, particularly under the chest muscles and on the right side of the helmet.

STEP 8

His left leg will catch a lot of light as it comes towards us, whereas his right leg will be in complete shadow. Don't render the shadow too dark on the furthest leg because it should fade into the distance a little to exaggerate the depth of the image.

Artist's tip

Plan your colours and composition first, and try doing some small colour roughs to explore all of your options.

STEP 9

Go for a red-orange colour scheme to reflect the fiery temperament of this powerful warrior. Rapidly block in the colour not worrying about the finish at this stage.

STEP 10

Roughly paint in areas of light and shade on the figure and liven up the shadows by adding lots of reflected red, especially on the breastplate. Loosely indicate the silhouette of an army in the background and for drama add some flames licking up around his legs.

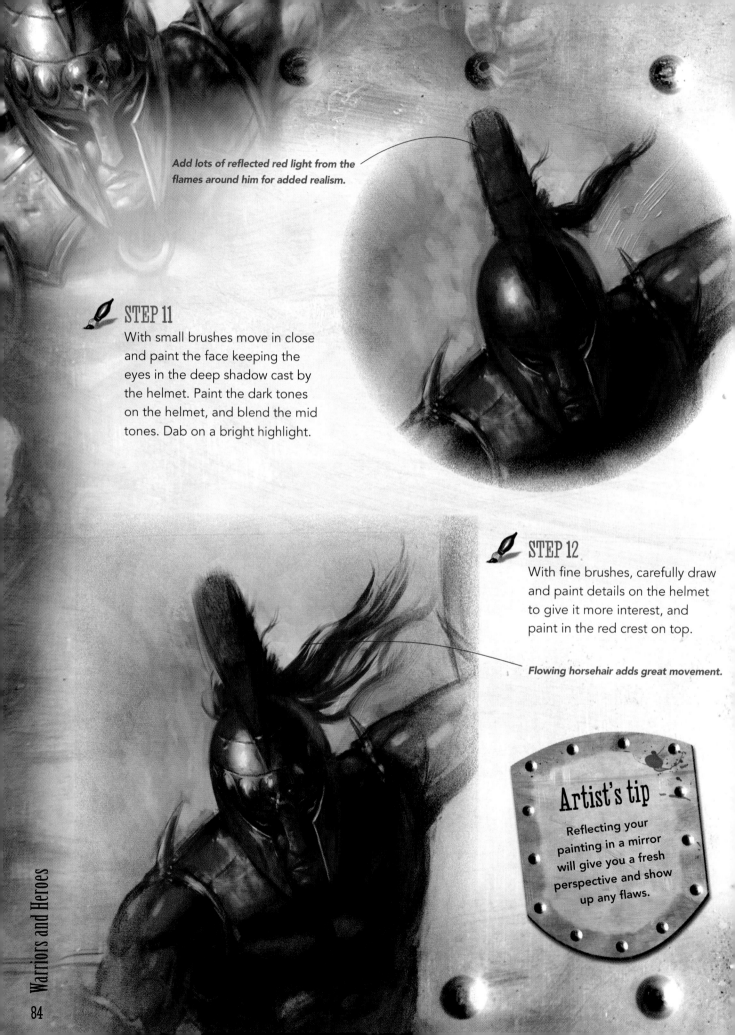

Add lots of reflected red light from the flames around him for added realism.

STEP 11

With small brushes move in close and paint the face keeping the eyes in the deep shadow cast by the helmet. Paint the dark tones on the helmet, and blend the mid tones. Dab on a bright highlight.

STEP 12

With fine brushes, carefully draw and paint details on the helmet to give it more interest, and paint in the red crest on top.

Flowing horsehair adds great movement.

Artist's tip

Reflecting your painting in a mirror will give you a fresh perspective and show up any flaws.

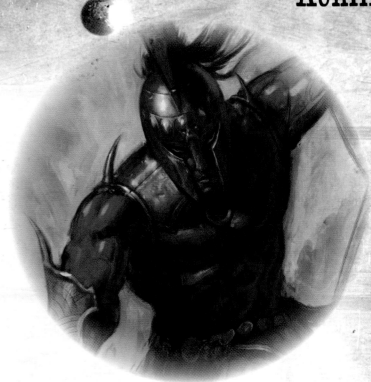

STEP 13

Move down to the torso defining the shapes on the breastplate with dark shadows, and mix bright red reflections on the underside of the muscle shapes. Then lay in the mid tones of the bronze colour where the light catches it, and finish with highlights on his right shoulder.

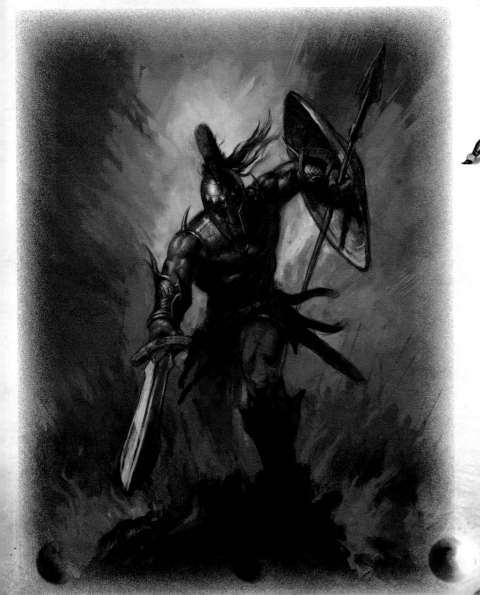

STEP 14

Model the sword arm and hand: you can imagine this as a straight tube coming out towards the viewer; it's the lumps and bumps of muscle that make it look like an arm. Lay down the shadows around the muscular forms and blend these into the middle flesh tones to render the correct shapes. Paint the shield arm and hand the same way, then finish off with the wrist guards.

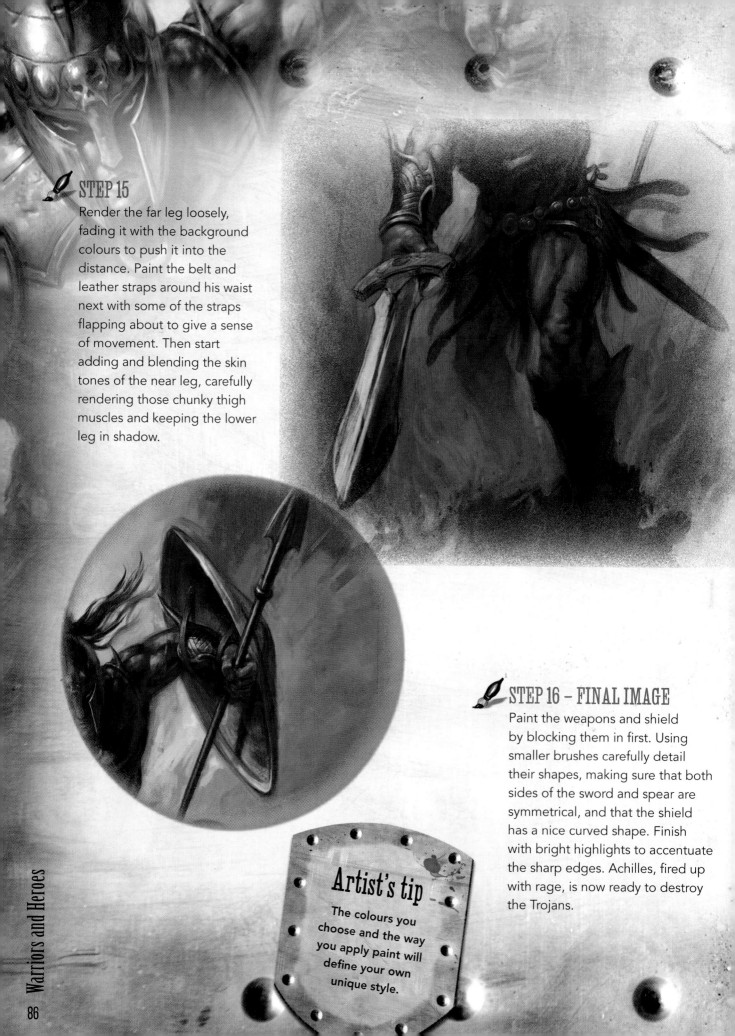

STEP 15

Render the far leg loosely, fading it with the background colours to push it into the distance. Paint the belt and leather straps around his waist next with some of the straps flapping about to give a sense of movement. Then start adding and blending the skin tones of the near leg, carefully rendering those chunky thigh muscles and keeping the lower leg in shadow.

STEP 16 – FINAL IMAGE

Paint the weapons and shield by blocking them in first. Using smaller brushes carefully detail their shapes, making sure that both sides of the sword and spear are symmetrical, and that the shield has a nice curved shape. Finish with bright highlights to accentuate the sharp edges. Achilles, fired up with rage, is now ready to destroy the Trojans.

Artist's tip

The colours you choose and the way you apply paint will define your own unique style.

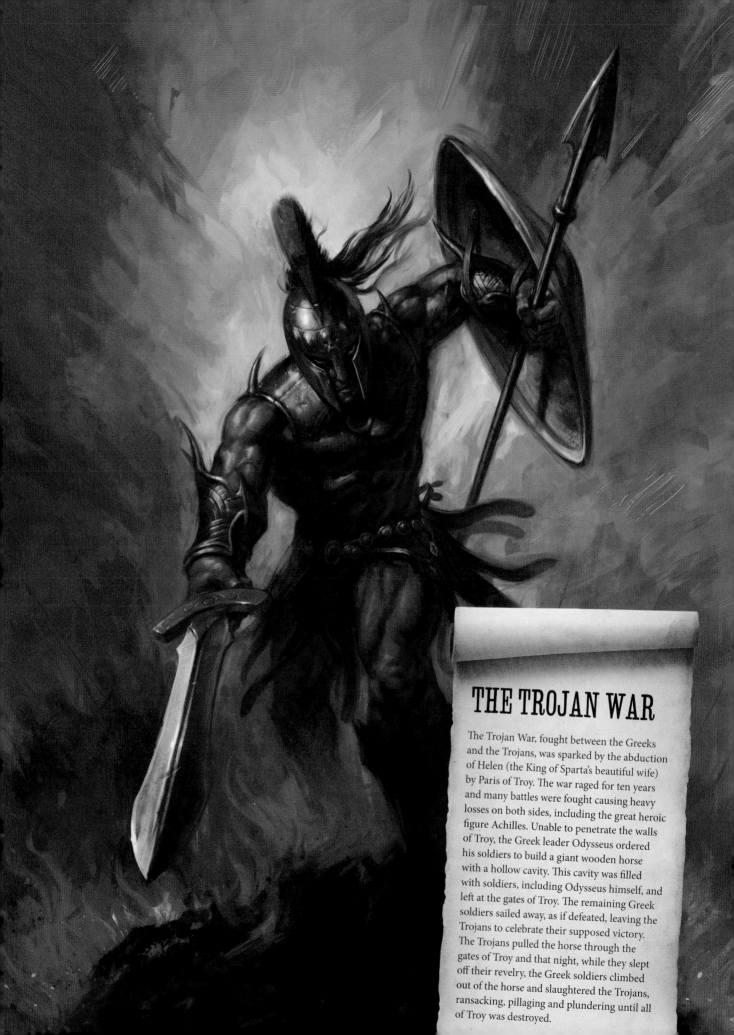

THE TROJAN WAR

The Trojan War, fought between the Greeks and the Trojans, was sparked by the abduction of Helen (the King of Sparta's beautiful wife) by Paris of Troy. The war raged for ten years and many battles were fought causing heavy losses on both sides, including the great heroic figure Achilles. Unable to penetrate the walls of Troy, the Greek leader Odysseus ordered his soldiers to build a giant wooden horse with a hollow cavity. This cavity was filled with soldiers, including Odysseus himself, and left at the gates of Troy. The remaining Greek soldiers sailed away, as if defeated, leaving the Trojans to celebrate their supposed victory. The Trojans pulled the horse through the gates of Troy and that night, while they slept off their revelry, the Greek soldiers climbed out of the horse and slaughtered the Trojans, ransacking, pillaging and plundering until all of Troy was destroyed.

Thor

This Norse God of Thunder, son of Odin and the Earth, had legendary strength, mysterious powers and a ferocious quick temper. As the strongest of the gods he was their protector, and armed with his mighty hammer Mjöllnir (meaning 'crusher'), he fought giants, serpents and trolls. A hammer built by dwarfs and endowed with magical powers, Mjöllnir became a natural extension of Thor; once thrown it would always return to its owner and it could restore life as well as destroy it. The crash of thunder is attributed to Thor riding through the heavens in his chariot; lightning would flash, so it was told, when he threw his powerful hammer.

> 'As his dread hammer shock
> Makes Earth and Heaven rock, Clouds rifting
> above, while Earth quakes below'
>
> *Valhalla (J.C. Jones)*

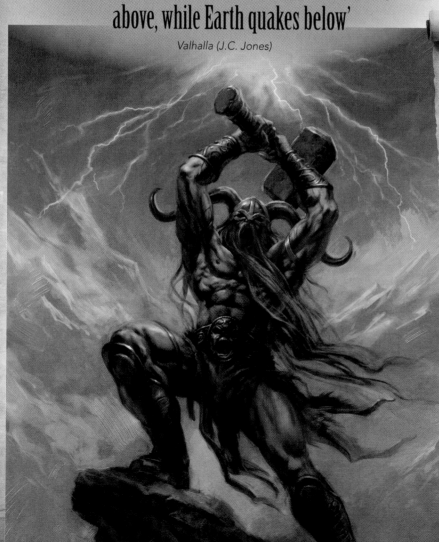

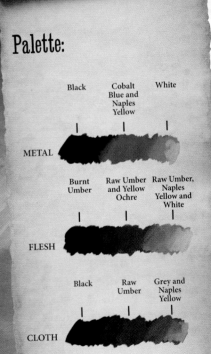

Palette:

	Black	Cobalt Blue and Naples Yellow	White
METAL			

	Burnt Umber	Raw Umber and Yellow Ochre	Raw Umber, Naples Yellow and White
FLESH			

	Black	Raw Umber	Grey and Naples Yellow
CLOTH			

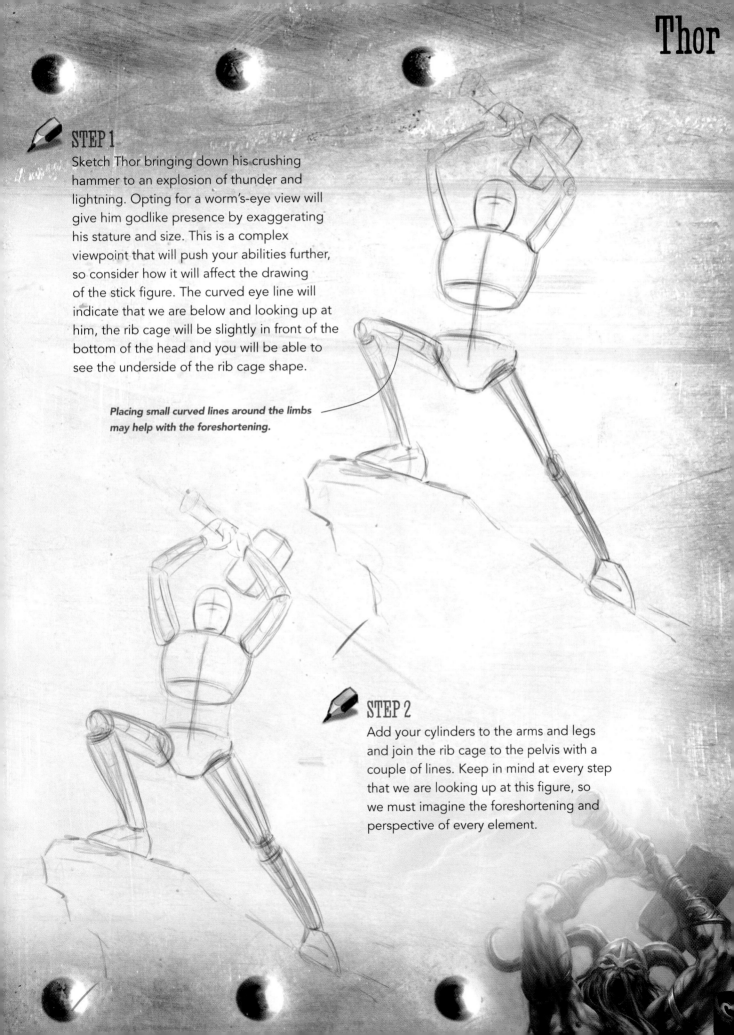

STEP 1

Sketch Thor bringing down his crushing hammer to an explosion of thunder and lightning. Opting for a worm's-eye view will give him godlike presence by exaggerating his stature and size. This is a complex viewpoint that will push your abilities further, so consider how it will affect the drawing of the stick figure. The curved eye line will indicate that we are below and looking up at him, the rib cage will be slightly in front of the bottom of the head and you will be able to see the underside of the rib cage shape.

Placing small curved lines around the limbs may help with the foreshortening.

STEP 2

Add your cylinders to the arms and legs and join the rib cage to the pelvis with a couple of lines. Keep in mind at every step that we are looking up at this figure, so we must imagine the foreshortening and perspective of every element.

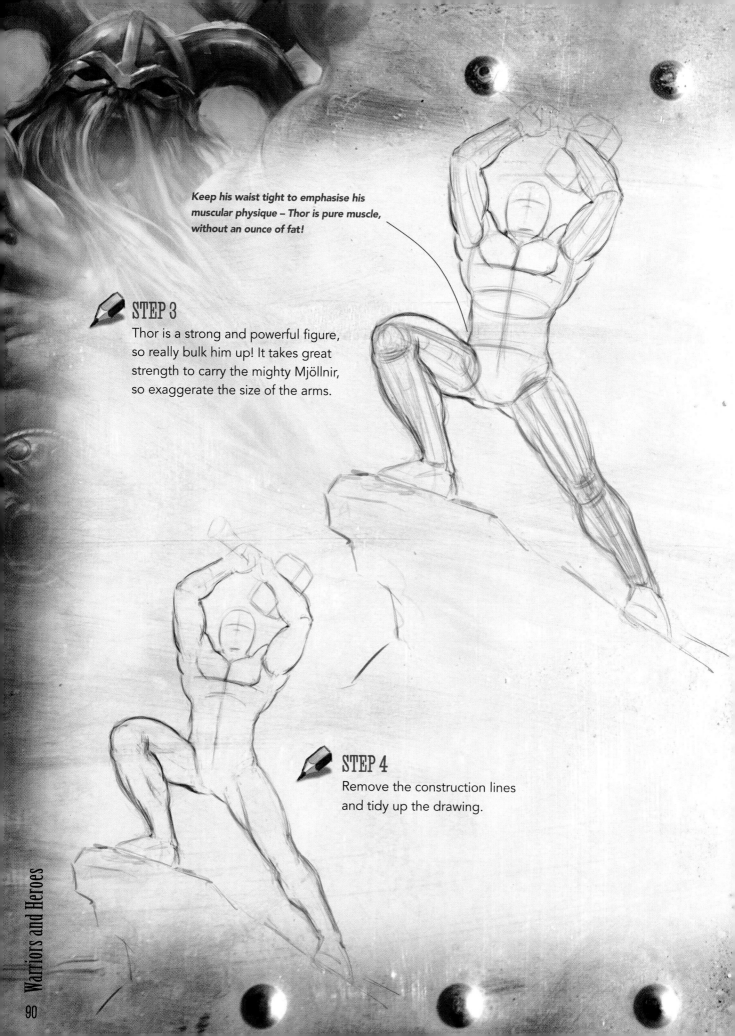

Keep his waist tight to emphasise his muscular physique – Thor is pure muscle, without an ounce of fat!

STEP 3

Thor is a strong and powerful figure, so really bulk him up! It takes great strength to carry the mighty Mjöllnir, so exaggerate the size of the arms.

STEP 4

Remove the construction lines and tidy up the drawing.

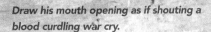

Draw his mouth opening as if shouting a blood curdling war cry.

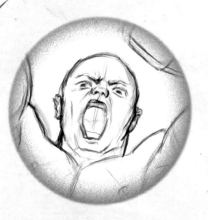

STEP 5

Drawing the face is tricky at this angle and it will help if you use a mirror. Tilt your head back slightly and notice how the distance between your eye line, tip of your nose and mouth is reduced the further back you go. Keep this in mind as you render the features. Add the detail on the rest of the figure, carefully drawing his hands gripping the handle of the hammer, a mirror might come in useful here too!

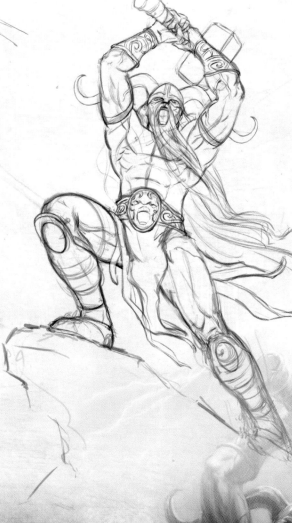

STEP 6

Dress this hellish heathen in a Viking helmet with massive horns, and give him a long flowing beard and hair. Wrap a pair of ornate gauntlets or wrist guards around his forearms and give him a couple of armoured greaves to protect his shins. Thor also wore a magic belt that doubled his strength, so draw one with an elaborate design, perhaps with a face echoing the war cry of the wearer.

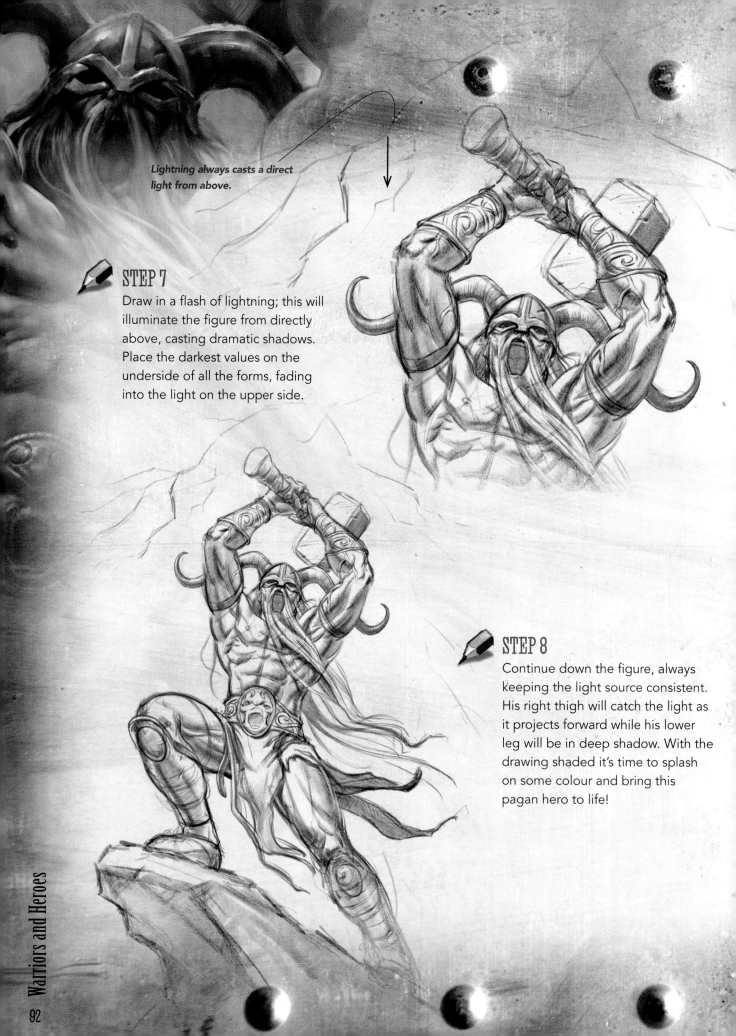

Lightning always casts a direct light from above.

STEP 7

Draw in a flash of lightning; this will illuminate the figure from directly above, casting dramatic shadows. Place the darkest values on the underside of all the forms, fading into the light on the upper side.

STEP 8

Continue down the figure, always keeping the light source consistent. His right thigh will catch the light as it projects forward while his lower leg will be in deep shadow. With the drawing shaded it's time to splash on some colour and bring this pagan hero to life!

STEP 9

A cool blue colour scheme will reflect the icy homeland of this Norse deity. Lay in the first pass of colour, blocking in your flats and allow the loose brushwork to suggest mountains in the background. Keep the skin tones cool and paint his hair and beard a light blonde colour.

STEP 10

Give the figure a second pass of colour, loosely washing in the darker and lighter areas with the appropriate tones. With the under painting done it's time to bring it all to a tighter finish.

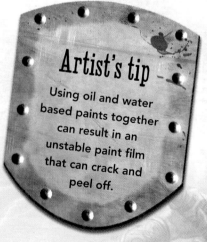

Artist's tip

Using oil and water based paints together can result in an unstable paint film that can crack and peel off.

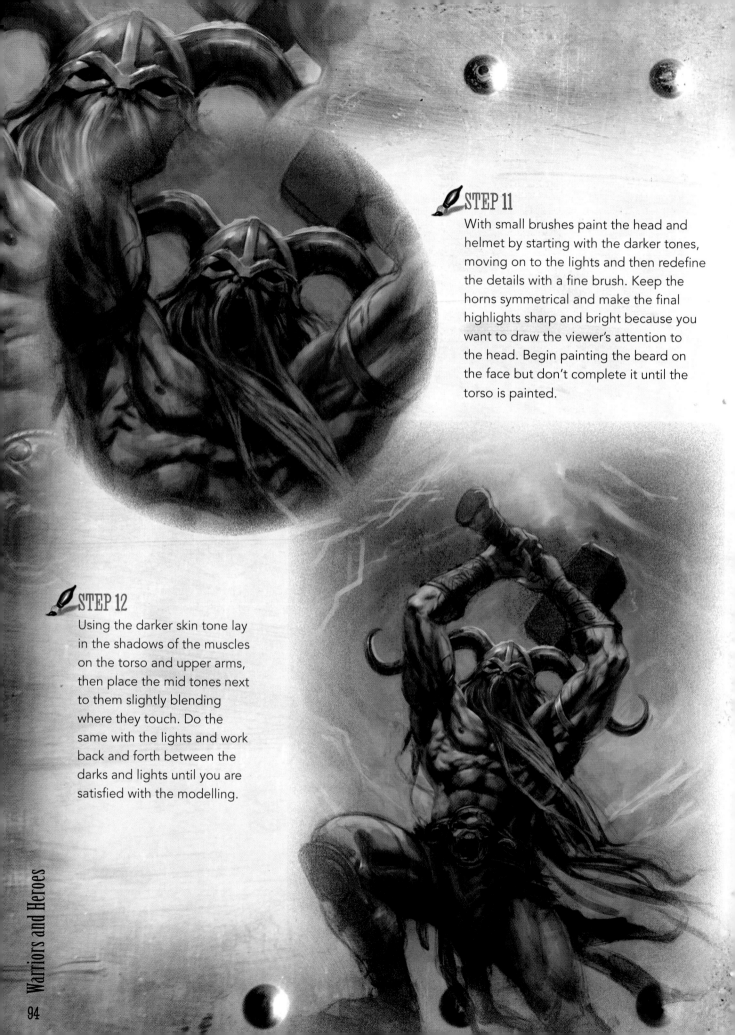

STEP 11

With small brushes paint the head and helmet by starting with the darker tones, moving on to the lights and then redefine the details with a fine brush. Keep the horns symmetrical and make the final highlights sharp and bright because you want to draw the viewer's attention to the head. Begin painting the beard on the face but don't complete it until the torso is painted.

STEP 12

Using the darker skin tone lay in the shadows of the muscles on the torso and upper arms, then place the mid tones next to them slightly blending where they touch. Do the same with the lights and work back and forth between the darks and lights until you are satisfied with the modelling.

 ## STEP 13

Now the torso is painted you can go back and finish that long flowing beard and hair. Use a medium-sized brush to paint in the darker parts first, dragging over the torso and into the background. Drag some of the background colour back into it to create a loose painterly effect, and do this until you are happy with the flowing shapes. With smaller brushes apply the lighter beard colour and finish by adding some individual hairs with a detail brush.

 ## STEP 14

Next, paint his wrist guards, hands and hammer. Model the wrist guards as metal cylinders first, before superimposing the pattern on top. Paint the hammerhead as an oblong block. The side facing away from the light will be very dark, and the side facing us will be a little lighter, and then add a bright outline along the top and side that will catch the light.

Artist's tip

If a painting is going wrong, take a break. Come back later with fresh eyes and the solution may seem obvious.

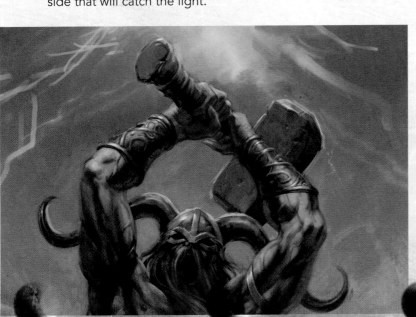

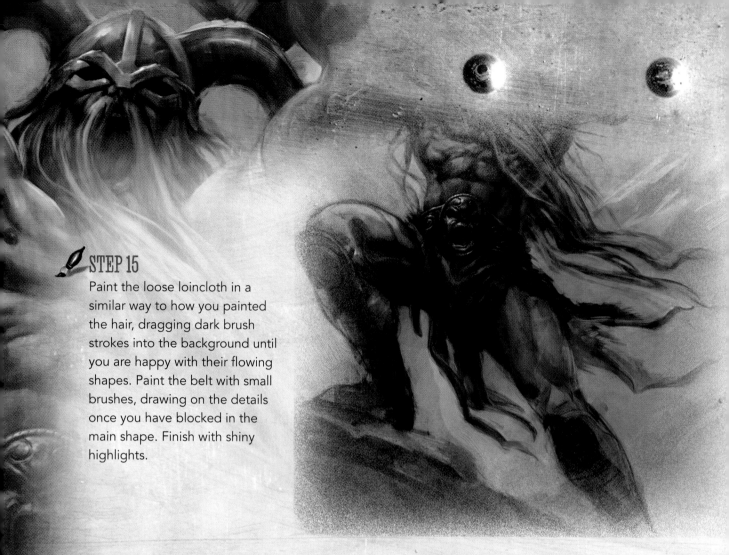

STEP 15

Paint the loose loincloth in a similar way to how you painted the hair, dragging dark brush strokes into the background until you are happy with their flowing shapes. Paint the belt with small brushes, drawing on the details once you have blocked in the main shape. Finish with shiny highlights.

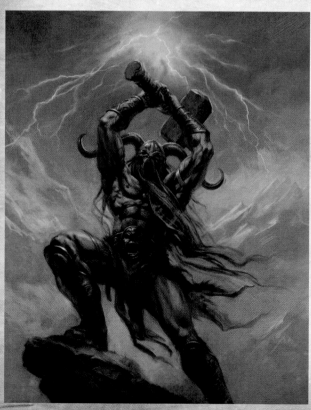

STEP 16 – FINAL IMAGE

Keep the legs relatively dark, except for the highlight on the thigh of the bent leg, and keep the handling quite loose. Loose brushwork is a great weapon in the artist's armoury of techniques; the viewer's attention will be drawn towards the tighter details and just glance over the looser areas. It's a question of personal style how much you make use of this technique. Finish the image by painting in the lightning and there you have it, Thor, bane of the frost giants, in all his glory!

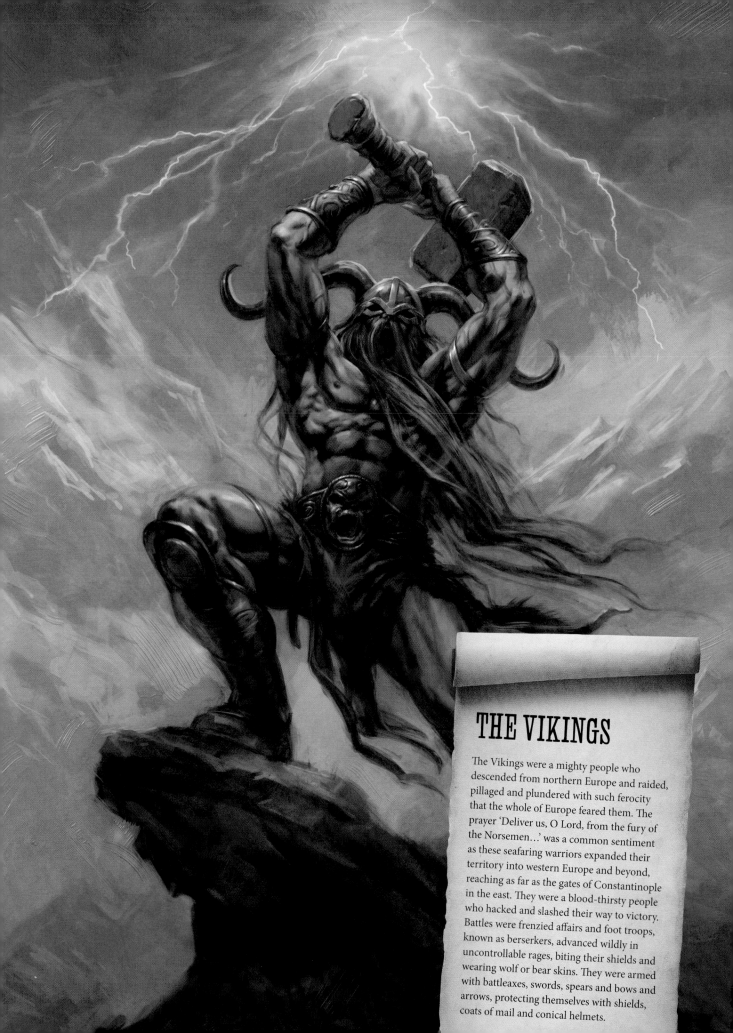

THE VIKINGS

The Vikings were a mighty people who descended from northern Europe and raided, pillaged and plundered with such ferocity that the whole of Europe feared them. The prayer 'Deliver us, O Lord, from the fury of the Norsemen…' was a common sentiment as these seafaring warriors expanded their territory into western Europe and beyond, reaching as far as the gates of Constantinople in the east. They were a blood-thirsty people who hacked and slashed their way to victory. Battles were frenzied affairs and foot troops, known as berserkers, advanced wildly in uncontrollable rages, biting their shields and wearing wolf or bear skins. They were armed with battleaxes, swords, spears and bows and arrows, protecting themselves with shields, coats of mail and conical helmets.

Apache

Hostile tribes of nomads with a warlike disposition, these native North American Indians raided European and Indian settlements alike for revenge and supplies. They would stealthily approach their enemy and attack under the cover of darkness, dressed in animal skins and armed with spears and bows with arrows dipped in a lethal poison obtained from snakes. These hunter-gatherers were deadly, and moved swiftly in pursuit of their prey, be it animal or human. Physical strength and resilience were commonly accepted characteristics as they stubbornly fought the colonisation of their land by the European settlers.

'Tigers of the human species'

General George Crook

Palette:

TROUSERS

- Burnt Umber
- Raw Umber and Yellow Ochre
- Raw Umber and Naples Yellow

STONE WEAPONS

- Black and Raw Umber
- Black, White and Raw Umber
- White

HEADBAND

- Burnt Umber and Crimson Alizarin
- Cadmium Red
- Naples Yellow and Cadmium Red

FLESH

- Burnt Umber and Crimson Alizarin
- Yellow Ochre and Light Red
- Naples Yellow

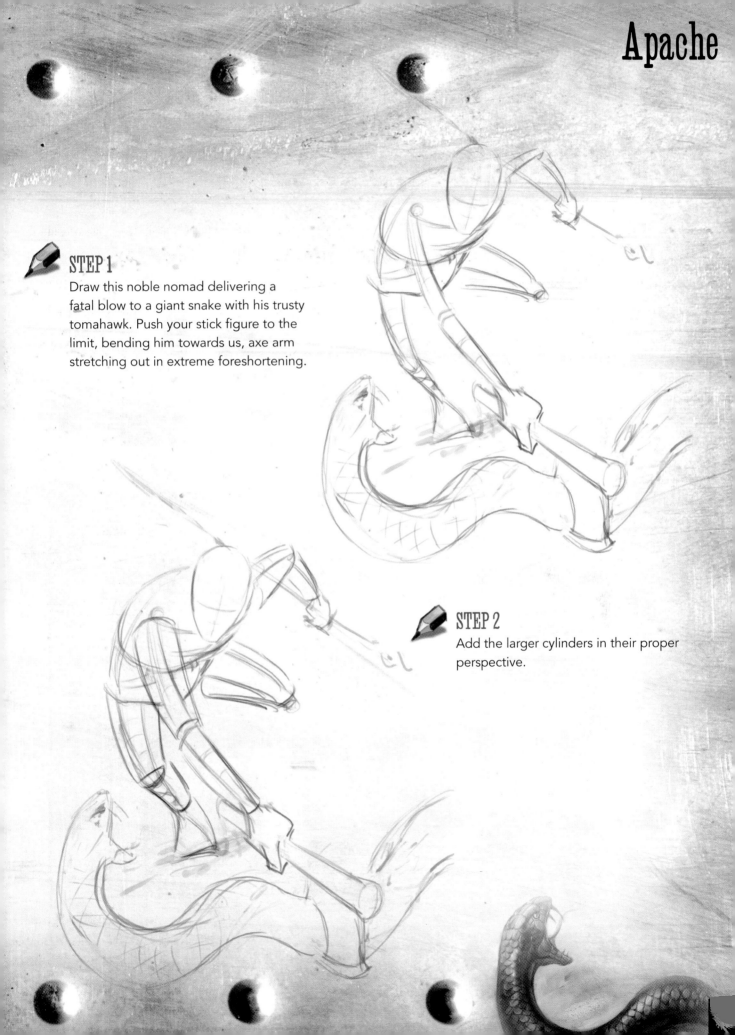

STEP 1

Draw this noble nomad delivering a fatal blow to a giant snake with his trusty tomahawk. Push your stick figure to the limit, bending him towards us, axe arm stretching out in extreme foreshortening.

STEP 2

Add the larger cylinders in their proper perspective.

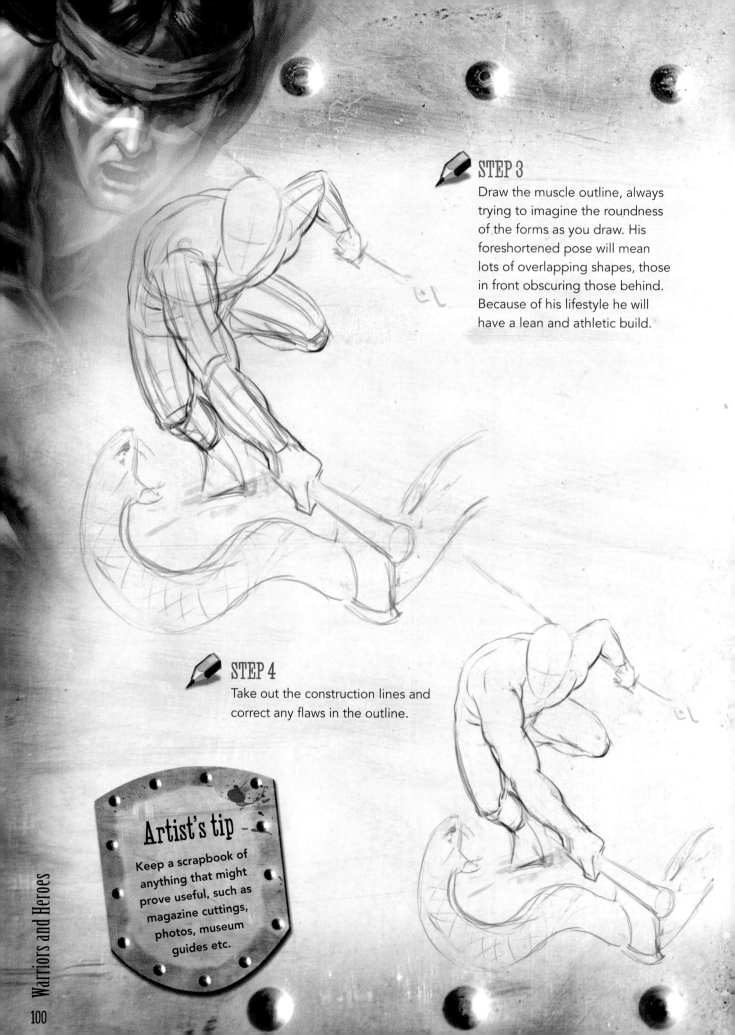

STEP 3

Draw the muscle outline, always trying to imagine the roundness of the forms as you draw. His foreshortened pose will mean lots of overlapping shapes, those in front obscuring those behind. Because of his lifestyle he will have a lean and athletic build.

STEP 4

Take out the construction lines and correct any flaws in the outline.

Artist's tip

Keep a scrapbook of anything that might prove useful, such as magazine cuttings, photos, museum guides etc.

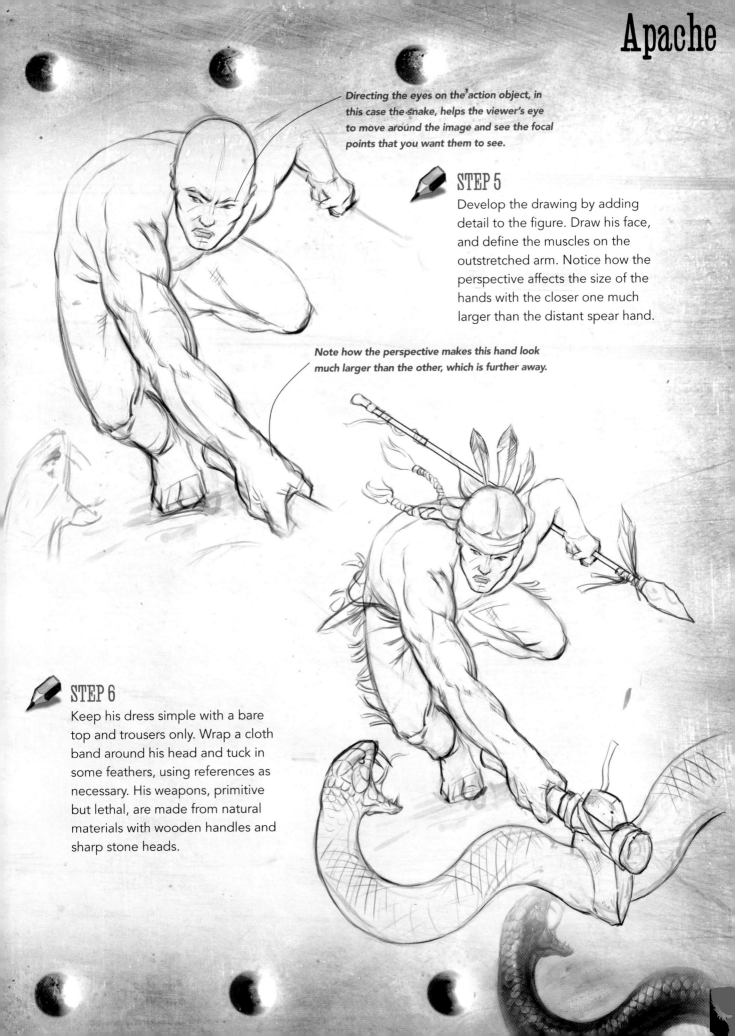

Directing the eyes on the action object, in this case the snake, helps the viewer's eye to move around the image and see the focal points that you want them to see.

STEP 5

Develop the drawing by adding detail to the figure. Draw his face, and define the muscles on the outstretched arm. Notice how the perspective affects the size of the hands with the closer one much larger than the distant spear hand.

Note how the perspective makes this hand look much larger than the other, which is further away.

STEP 6

Keep his dress simple with a bare top and trousers only. Wrap a cloth band around his head and tuck in some feathers, using references as necessary. His weapons, primitive but lethal, are made from natural materials with wooden handles and sharp stone heads.

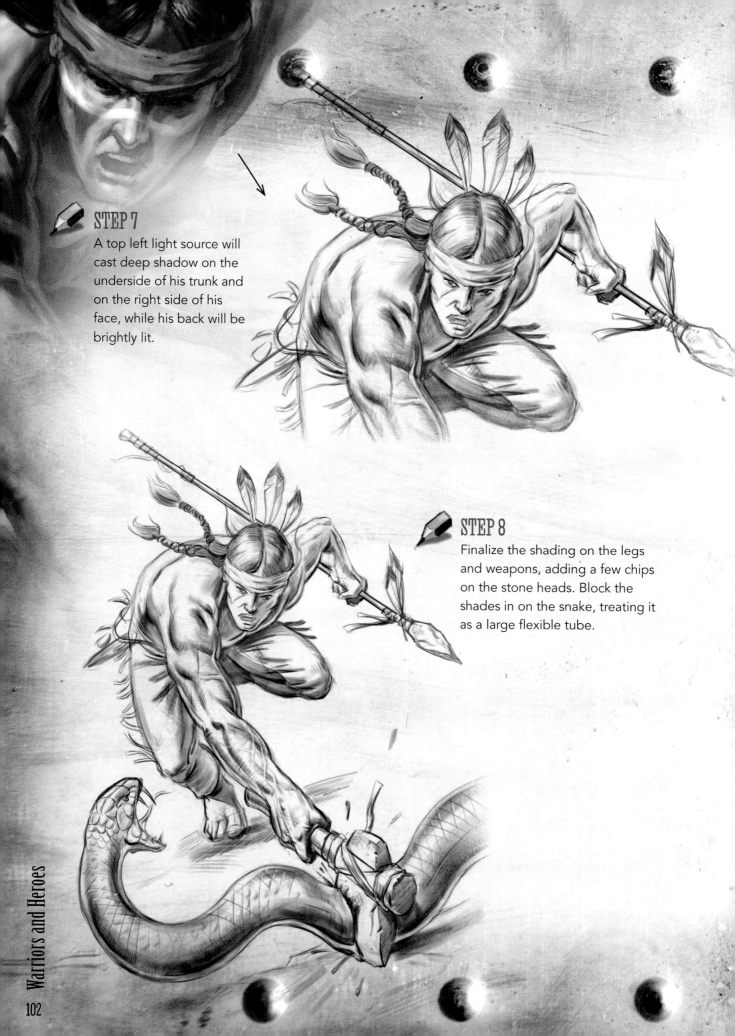

STEP 7

A top left light source will cast deep shadow on the underside of his trunk and on the right side of his face, while his back will be brightly lit.

STEP 8

Finalize the shading on the legs and weapons, adding a few chips on the stone heads. Block the shades in on the snake, treating it as a large flexible tube.

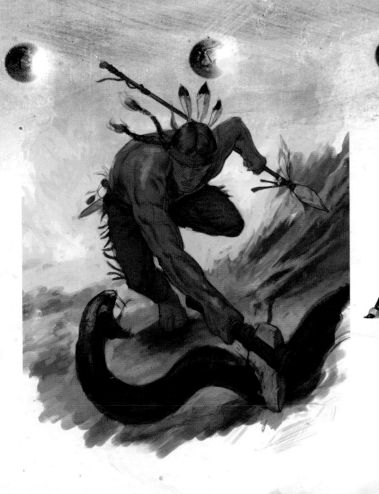

STEP 9

Rapidly wash in the basic colours giving him a dark, tanned skin tone, together with a bright red headband that will grab the attention of the viewer. Make the background a dusty brown ochre colour and block the snake in with dark umber.

STEP 10

Give volume to the figure by very roughly indicating light and shade, and liven up the shadows with the addition of some bright red reflections. This will raise the temperature of the picture and help add drama to the image.

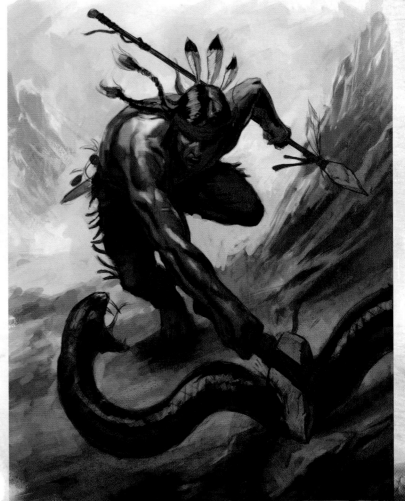

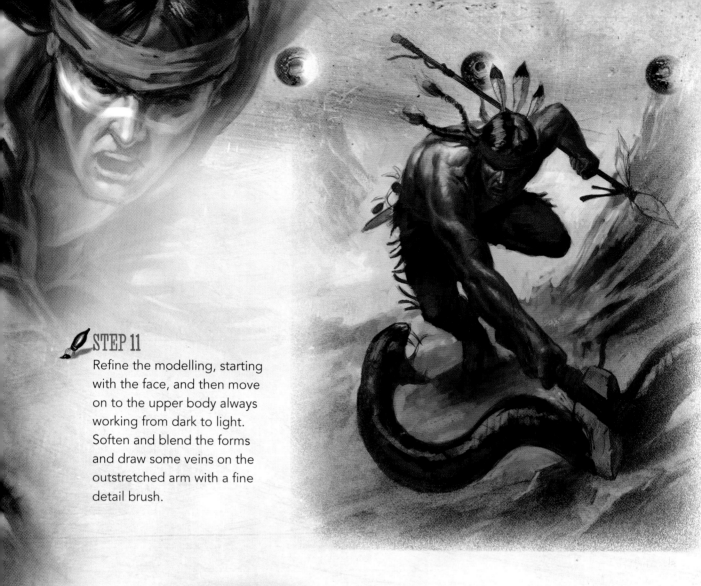

STEP 11

Refine the modelling, starting with the face, and then move on to the upper body always working from dark to light. Soften and blend the forms and draw some veins on the outstretched arm with a fine detail brush.

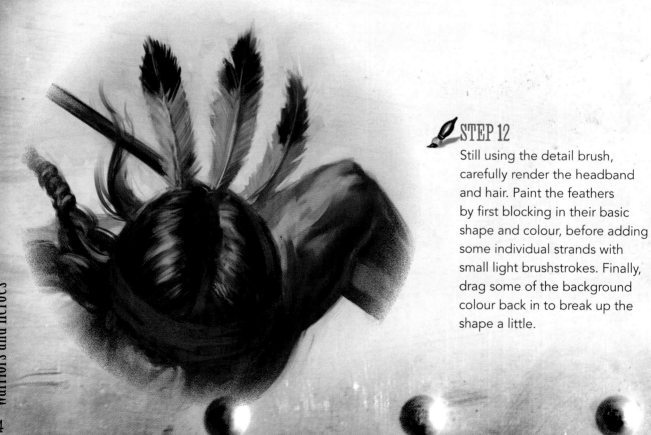

STEP 12

Still using the detail brush, carefully render the headband and hair. Paint the feathers by first blocking in their basic shape and colour, before adding some individual strands with small light brushstrokes. Finally, drag some of the background colour back in to break up the shape a little.

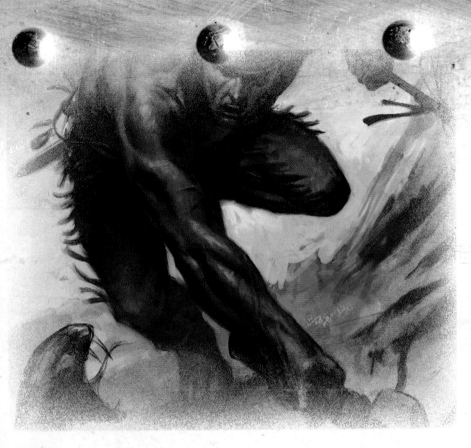

Artist's tip

Once you have a firm grasp of the rules, don't be afraid to break them! Explore and find your own style.

STEP 13

Now paint the legs, fading his right leg with the background colour to give the impression of dust being kicked up in the skirmish.

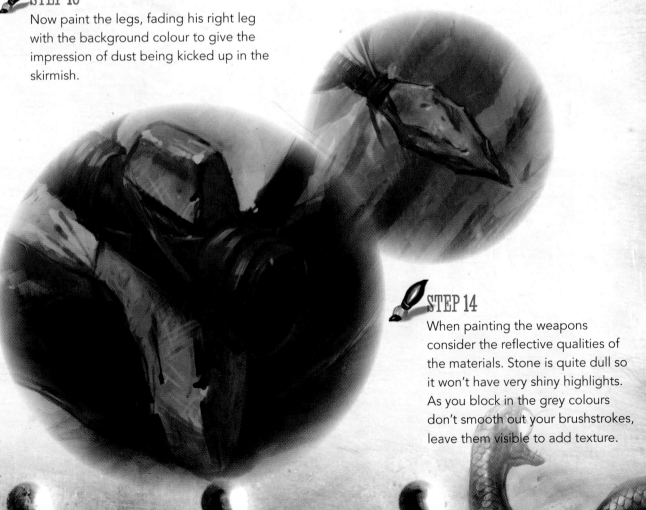

STEP 14

When painting the weapons consider the reflective qualities of the materials. Stone is quite dull so it won't have very shiny highlights. As you block in the grey colours don't smooth out your brushstrokes, leave them visible to add texture.

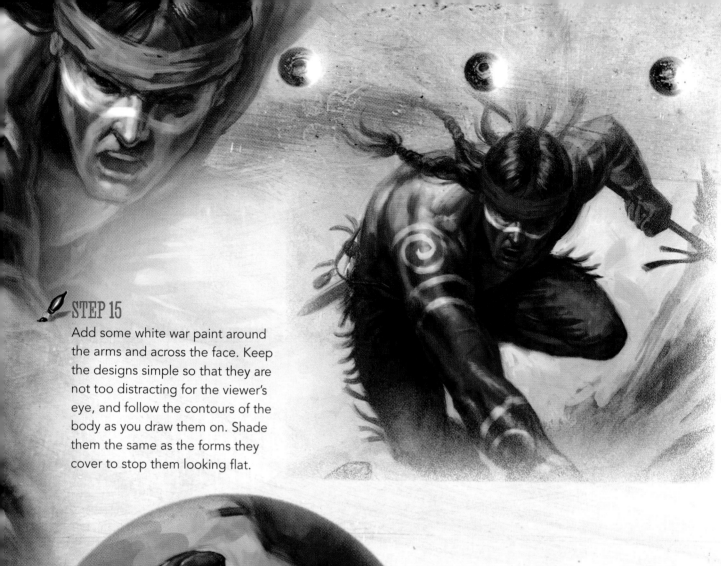

STEP 15

Add some white war paint around the arms and across the face. Keep the designs simple so that they are not too distracting for the viewer's eye, and follow the contours of the body as you draw them on. Shade them the same as the forms they cover to stop them looking flat.

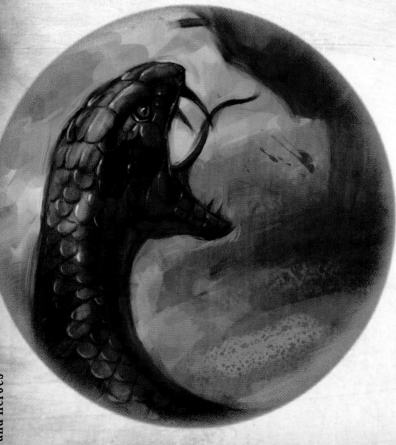

STEP 16 – FINAL IMAGE

All that is left is the deadly snake and the image is done. Always stand back and view the image as a whole when you have finished a painting. There may be some areas that need sharpening or some that need softening; never be afraid to dive back in and change something if you feel it isn't working, but be disciplined about knowing when to stop.

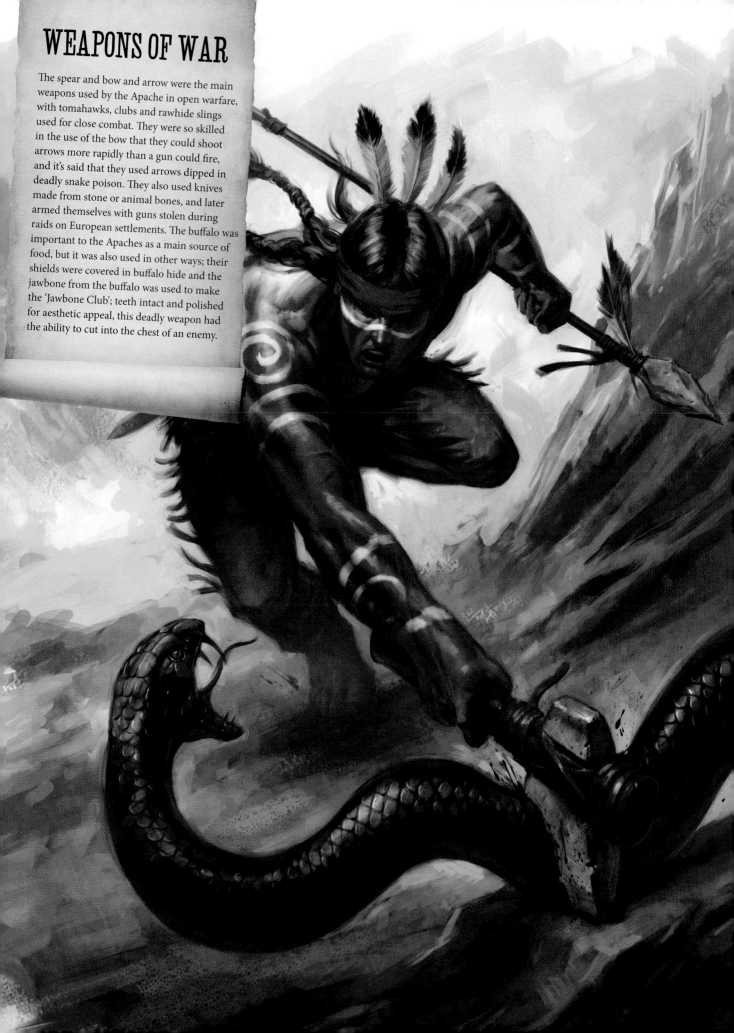

WEAPONS OF WAR

The spear and bow and arrow were the main weapons used by the Apache in open warfare, with tomahawks, clubs and rawhide slings used for close combat. They were so skilled in the use of the bow that they could shoot arrows more rapidly than a gun could fire, and it's said that they used arrows dipped in deadly snake poison. They also used knives made from stone or animal bones, and later armed themselves with guns stolen during raids on European settlements. The buffalo was important to the Apaches as a main source of food, but it was also used in other ways; their shields were covered in buffalo hide and the jawbone from the buffalo was used to make the 'Jawbone Club'; teeth intact and polished for aesthetic appeal, this deadly weapon had the ability to cut into the chest of an enemy.

Gladiator

In the Roman Empire, gladiators were slaves or captured soldier-prisoners who were professionally trained to fight in the lavish gladiatorial games set up to amuse and entertain the bloodthirsty Romans. The word 'gladiator' derives from gladius, the sword they commonly used, but they also went in armed with war chains, nets, tridents, daggers and lassos. They fought for fame and glory, and ultimately life. It was a brutal kind of showmanship; performed by men whose very existence pivoted on their physical prowess, combat skill and a flair for gaining the favour of the savage audience. A gladiator's wish was to die well in the event of defeat; victory, however, brought fame, adulation and riches although few survived past their thirties to enjoy such rewards.

'I see before me the Gladiator lie:
He leans upon his hand — his manly brow
Consents to death, but conquers agony.'

Lord Byron

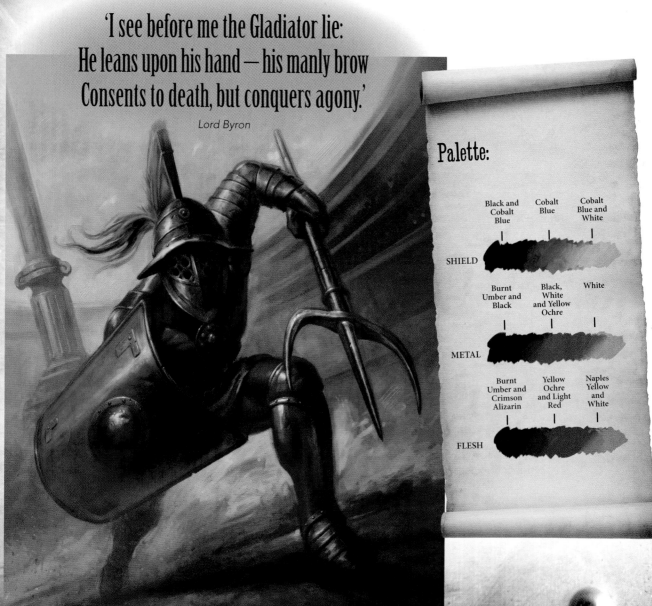

Palette:

SHIELD
- Black and Cobalt Blue
- Cobalt Blue
- Cobalt Blue and White

METAL
- Burnt Umber and Black
- Black, White and Yellow Ochre
- White

FLESH
- Burnt Umber and Crimson Alizarin
- Yellow Ochre and Light Red
- Naples Yellow and White

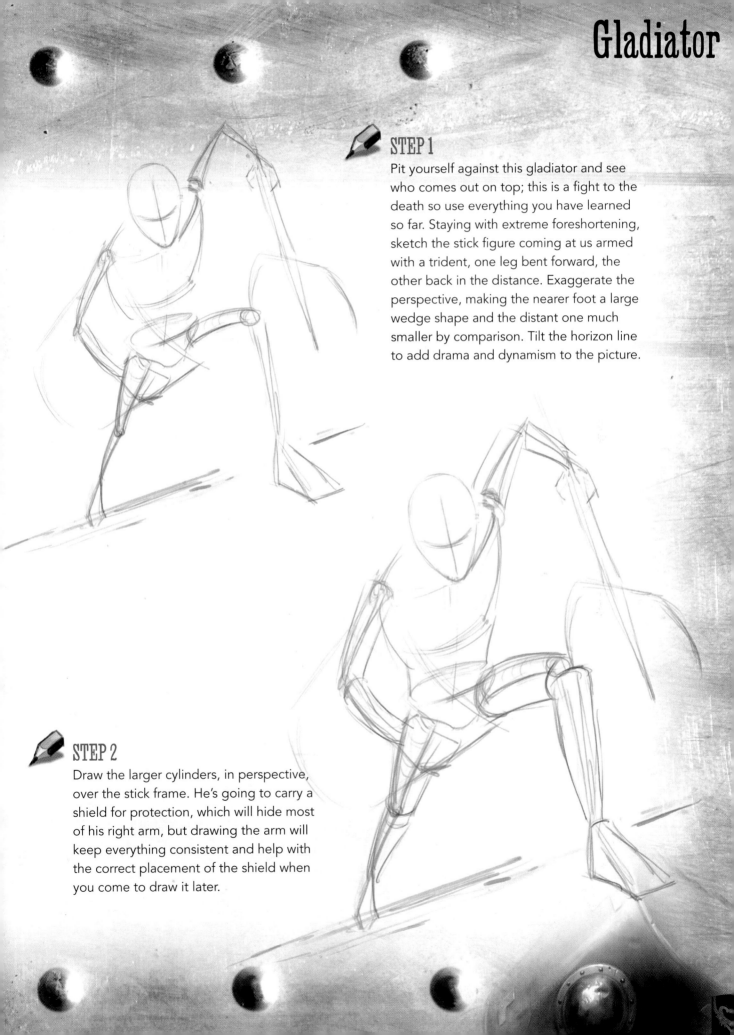

Gladiator

STEP 1

Pit yourself against this gladiator and see who comes out on top; this is a fight to the death so use everything you have learned so far. Staying with extreme foreshortening, sketch the stick figure coming at us armed with a trident, one leg bent forward, the other back in the distance. Exaggerate the perspective, making the nearer foot a large wedge shape and the distant one much smaller by comparison. Tilt the horizon line to add drama and dynamism to the picture.

STEP 2

Draw the larger cylinders, in perspective, over the stick frame. He's going to carry a shield for protection, which will hide most of his right arm, but drawing the arm will keep everything consistent and help with the correct placement of the shield when you come to draw it later.

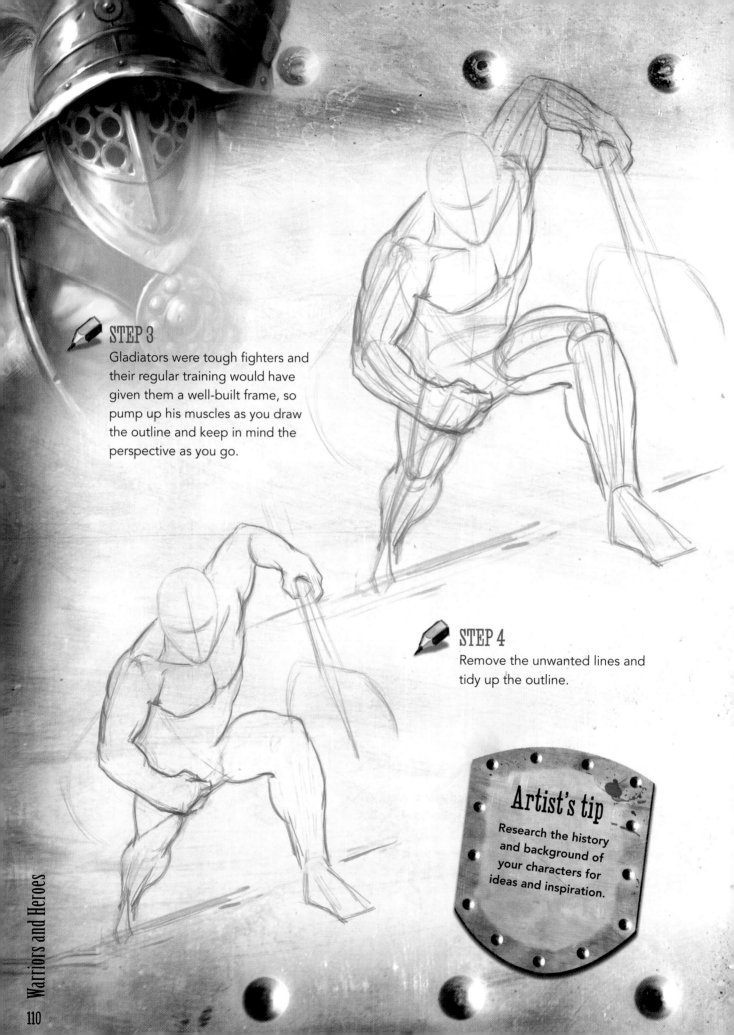

STEP 3

Gladiators were tough fighters and their regular training would have given them a well-built frame, so pump up his muscles as you draw the outline and keep in mind the perspective as you go.

STEP 4

Remove the unwanted lines and tidy up the outline.

Artist's tip

Research the history and background of your characters for ideas and inspiration.

STEP 5

Detail the facial features and musculature. His face will be totally covered by his helmet but draw the features to help place it correctly.

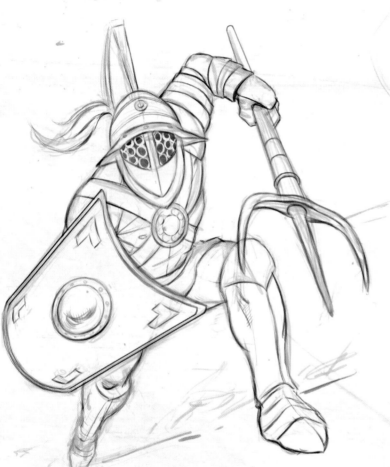

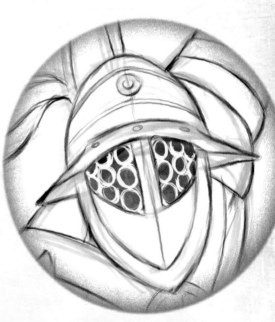

STEP 6

Go for the classic murmillo-style gladiator helmet. The head is totally encased in this magnificent helmet, which has a grill for the fighter to see out of. It's quite a complicated design with a wide brim and a crest on top, so it will help if you can find some reference. Protect his weapon arm with plated armour and give him greaves for his legs. Draw in a Roman legionary shield and, along with the trident, make sure these are in the correct perspective.

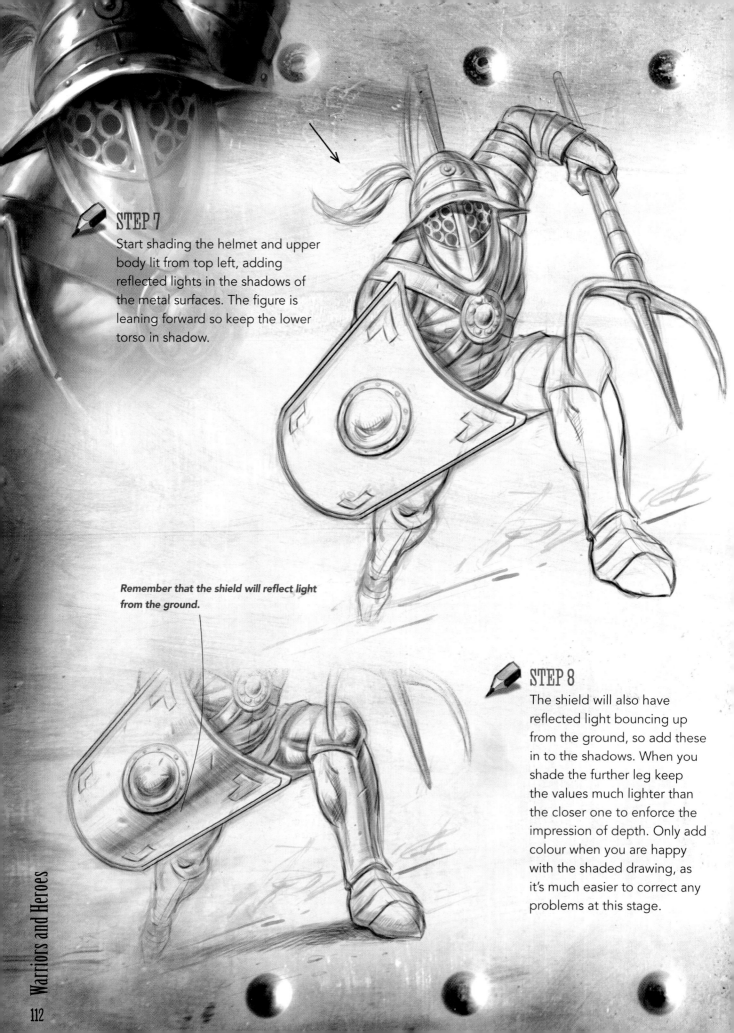

STEP 7

Start shading the helmet and upper body lit from top left, adding reflected lights in the shadows of the metal surfaces. The figure is leaning forward so keep the lower torso in shadow.

Remember that the shield will reflect light from the ground.

STEP 8

The shield will also have reflected light bouncing up from the ground, so add these in to the shadows. When you shade the further leg keep the values much lighter than the closer one to enforce the impression of depth. Only add colour when you are happy with the shaded drawing, as it's much easier to correct any problems at this stage.

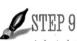

STEP 9

A bright blue Mediterranean sky and light dusty browns will provide a suitable palette, and as you block in the colours, loosely indicate that he is in an arena. Give him a tanned orangey skin tone, and paint the shield blue to harmonize with the sky. The metal will be quite bright in this setting as it reflects the light and surrounding colours.

STEP 10

You should know the drill by now; loosely wash in the lights and darks to add roundness and volume to the figure. Add some more detail to the background.

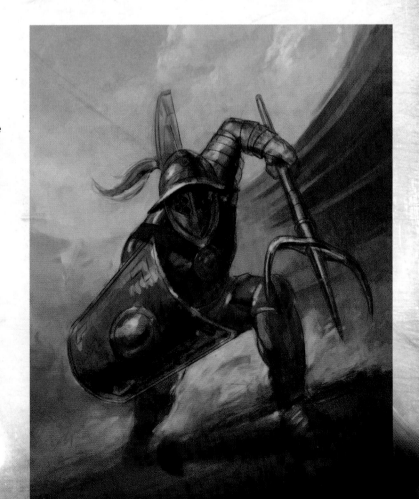

Artist's tip

Approach each piece of work boldly, and don't be afraid to make mistakes, otherwise you won't learn.

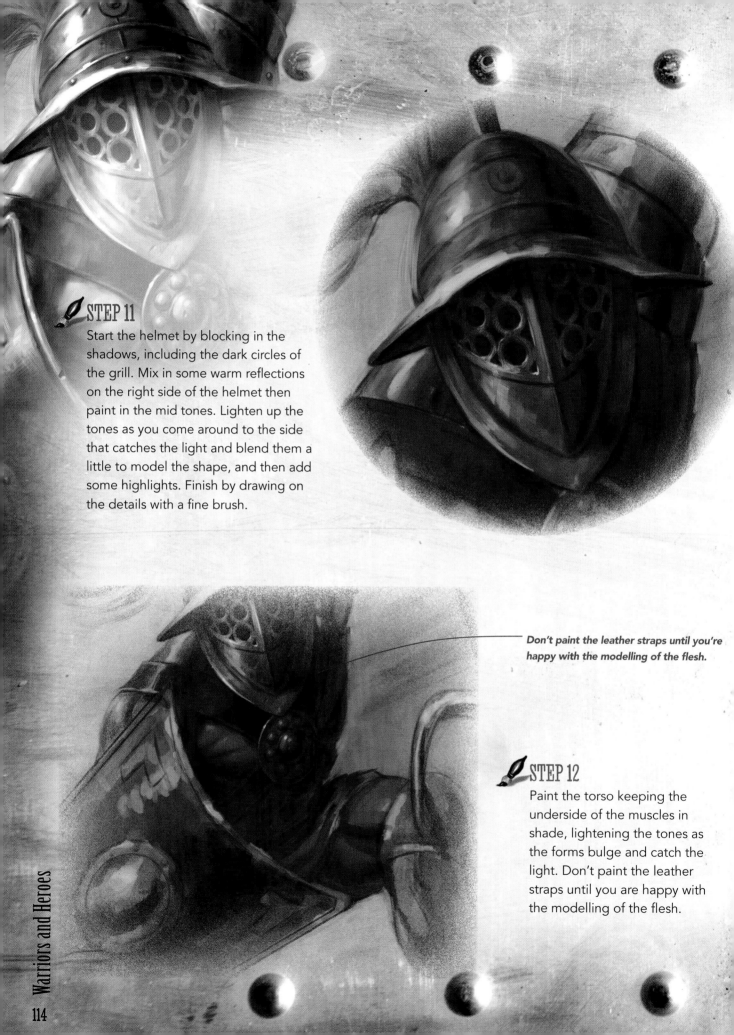

STEP 11

Start the helmet by blocking in the shadows, including the dark circles of the grill. Mix in some warm reflections on the right side of the helmet then paint in the mid tones. Lighten up the tones as you come around to the side that catches the light and blend them a little to model the shape, and then add some highlights. Finish by drawing on the details with a fine brush.

Don't paint the leather straps until you're happy with the modelling of the flesh.

STEP 12

Paint the torso keeping the underside of the muscles in shade, lightening the tones as the forms bulge and catch the light. Don't paint the leather straps until you are happy with the modelling of the flesh.

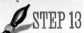 ## STEP 13

Treat the separate plates on the armoured arm as one single plate initially – brush in the darks, mid tones and lights following the forms with your brushstrokes. As this is metal make sure there is a high contrast between your lights and darks, and add some warm reflections in the shadows. Once you have moulded the correct form of the arm, carefully draw on the lines that separate the plates with a detail brush.

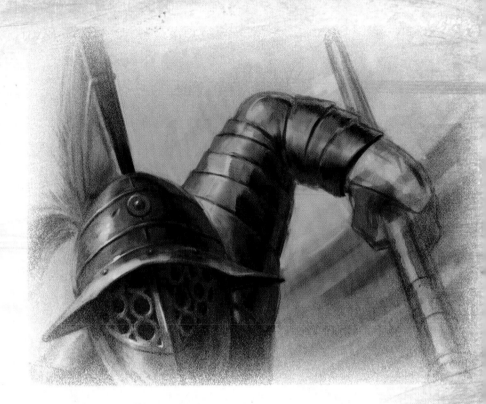

STEP 14

Paint the forward leg first, keeping the lights bright, the darks dark and the detail sharp. Then paint the further leg in a much looser way, fading the colours into the background to help give the impression of distance.

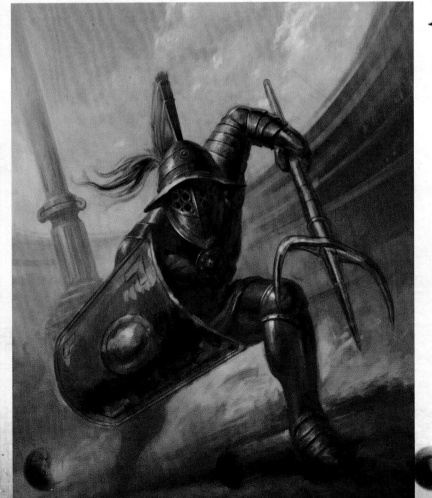

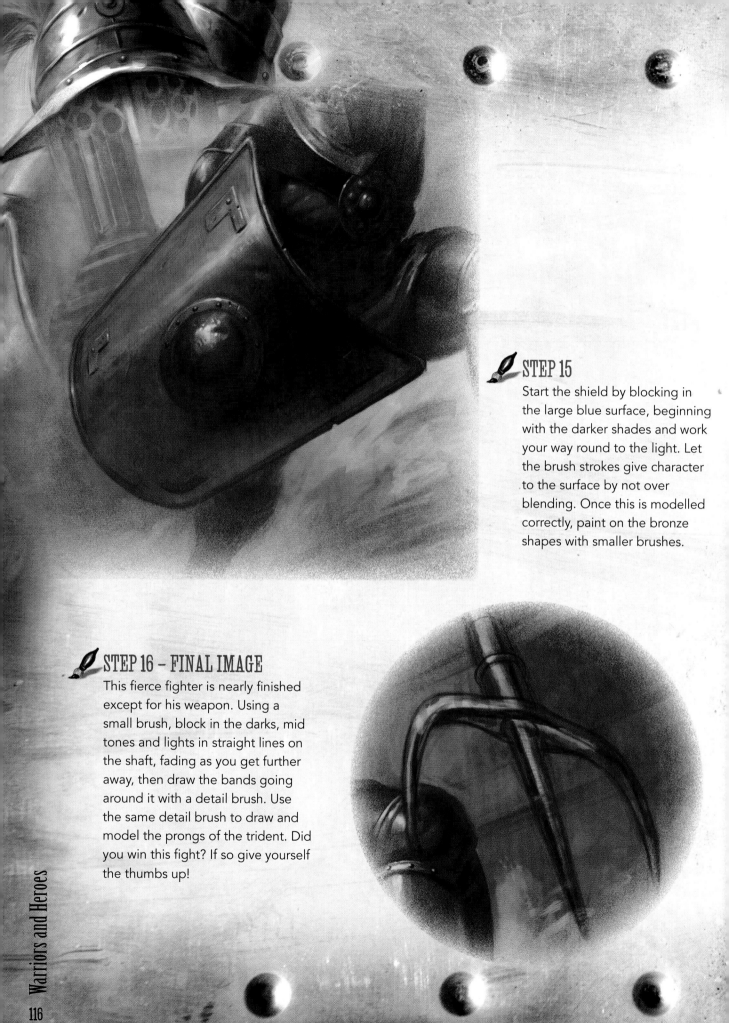

STEP 15

Start the shield by blocking in the large blue surface, beginning with the darker shades and work your way round to the light. Let the brush strokes give character to the surface by not over blending. Once this is modelled correctly, paint on the bronze shapes with smaller brushes.

STEP 16 – FINAL IMAGE

This fierce fighter is nearly finished except for his weapon. Using a small brush, block in the darks, mid tones and lights in straight lines on the shaft, fading as you get further away, then draw the bands going around it with a detail brush. Use the same detail brush to draw and model the prongs of the trident. Did you win this fight? If so give yourself the thumbs up!

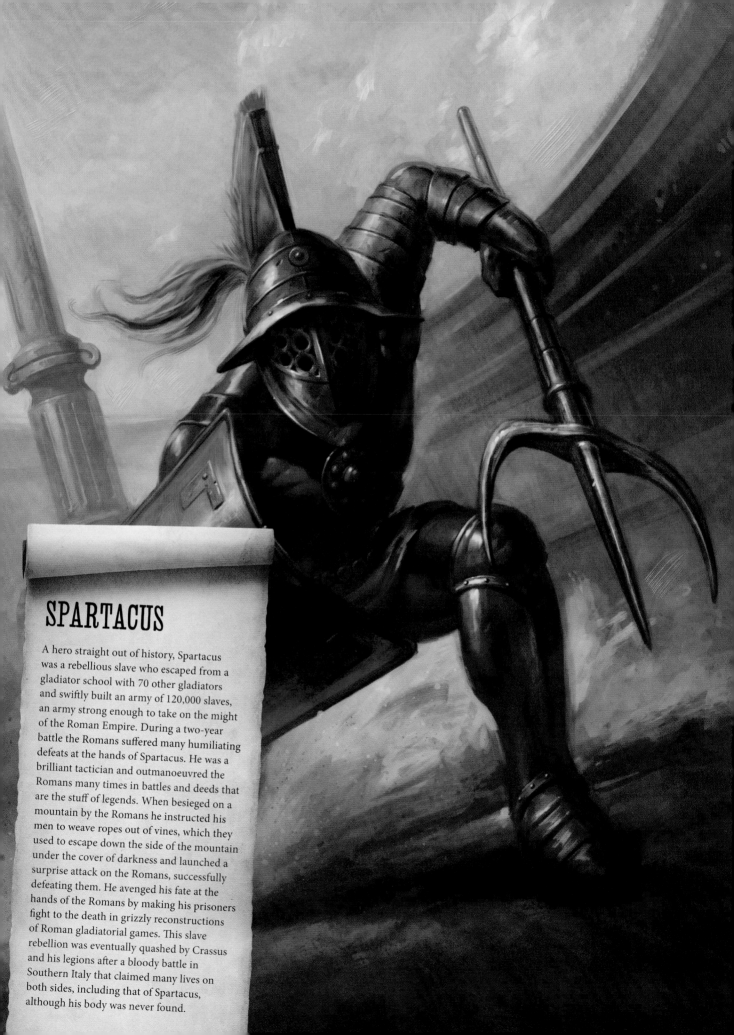

SPARTACUS

A hero straight out of history, Spartacus was a rebellious slave who escaped from a gladiator school with 70 other gladiators and swiftly built an army of 120,000 slaves, an army strong enough to take on the might of the Roman Empire. During a two-year battle the Romans suffered many humiliating defeats at the hands of Spartacus. He was a brilliant tactician and outmanoeuvred the Romans many times in battles and deeds that are the stuff of legends. When besieged on a mountain by the Romans he instructed his men to weave ropes out of vines, which they used to escape down the side of the mountain under the cover of darkness and launched a surprise attack on the Romans, successfully defeating them. He avenged his fate at the hands of the Romans by making his prisoners fight to the death in grizzly reconstructions of Roman gladiatorial games. This slave rebellion was eventually quashed by Crassus and his legions after a bloody battle in Southern Italy that claimed many lives on both sides, including that of Spartacus, although his body was never found.

Medieval Knight

Dressed head to foot in steel plate armour, wielding mighty swords, axes, hammers and a menagerie of weaponry, these imposing warriors would have been a fearsome sight on the battlefield. Although guided by a chivalric code of conduct which demanded loyalty, religious devotion and protection of the weak, knights were first and foremost elite warriors. They spent many years in training where they mastered the art of swordsmanship and learned how to wrestle and handle a horse during combat. A knight relied heavily on his armour and weapons for protection, and it's precisely these that make him such an interesting warrior to draw and paint.

'Be bold and protect the people, be loyal and valiant, taking nothing from others. Thus should a Knight rule himself.'

Eustache Deschamps

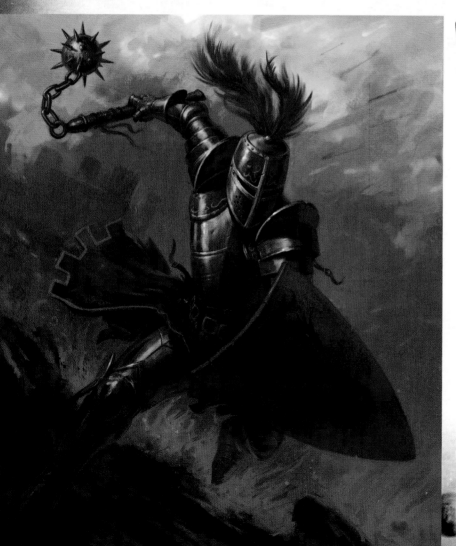

Palette:

PLUME AND SHIELD

Burnt Umber and Crimson Alizarin	Cadmium Red and Crimson Alizarin	Crimson Alizarin and Naples Yellow

CLOTH

Burnt Umber and Crimson Alizarin	Yellow Ochre and Crimson Alizarin	Yellow Ochre and Cadmium Red

ARMOUR

Black and Burnt Umber	Black, White and Yellow Ochre	White and Naples Yellow

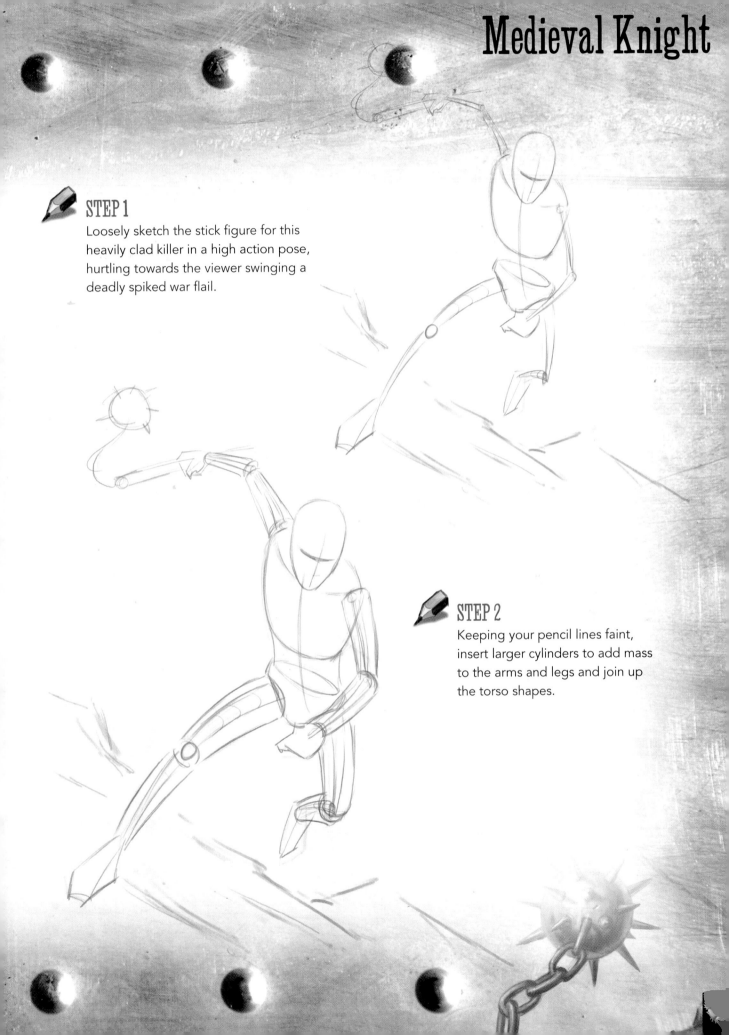

STEP 1

Loosely sketch the stick figure for this heavily clad killer in a high action pose, hurtling towards the viewer swinging a deadly spiked war flail.

STEP 2

Keeping your pencil lines faint, insert larger cylinders to add mass to the arms and legs and join up the torso shapes.

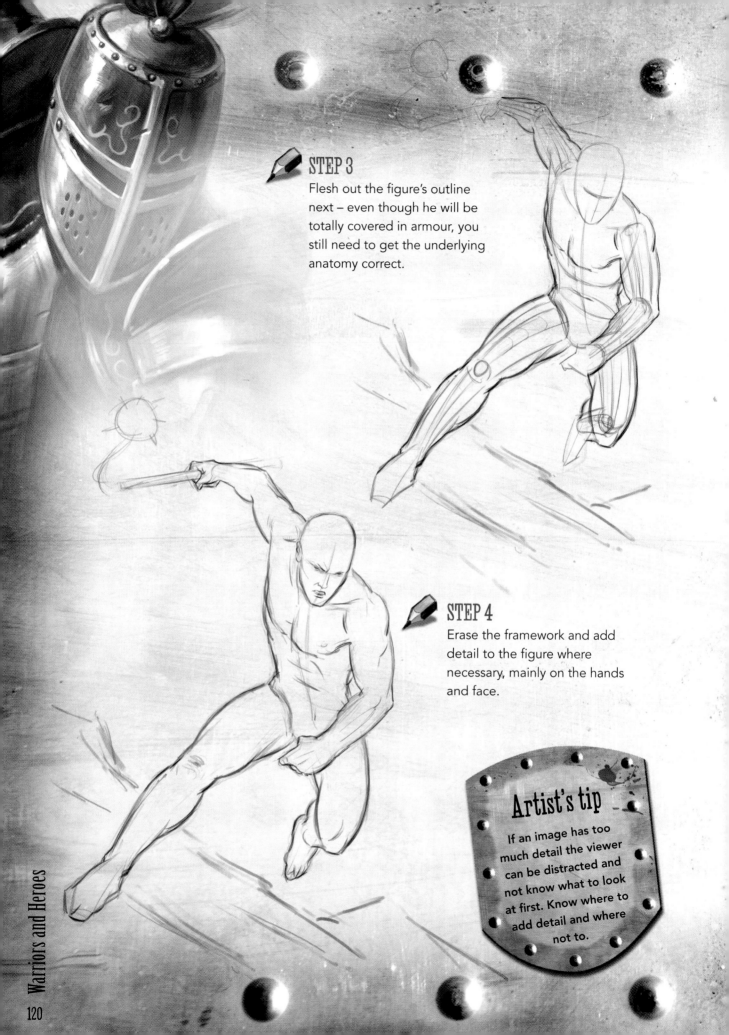

STEP 3

Flesh out the figure's outline next – even though he will be totally covered in armour, you still need to get the underlying anatomy correct.

STEP 4

Erase the framework and add detail to the figure where necessary, mainly on the hands and face.

Artist's tip

If an image has too much detail the viewer can be distracted and not know what to look at first. Know where to add detail and where not to.

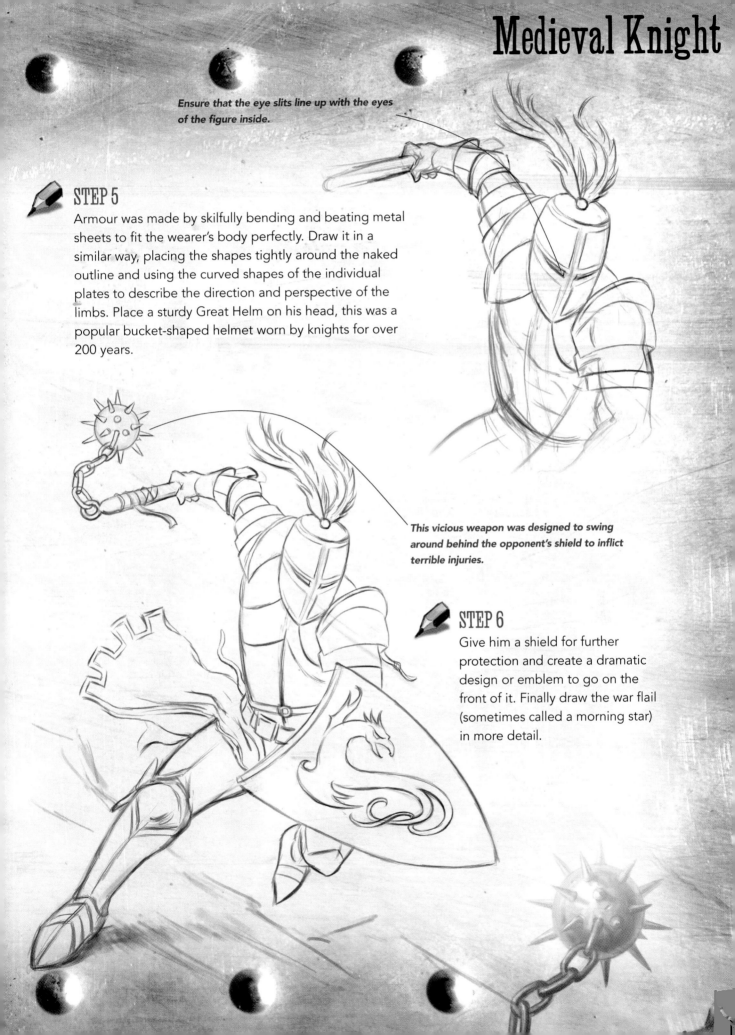

Ensure that the eye slits line up with the eyes of the figure inside.

STEP 5

Armour was made by skilfully bending and beating metal sheets to fit the wearer's body perfectly. Draw it in a similar way, placing the shapes tightly around the naked outline and using the curved shapes of the individual plates to describe the direction and perspective of the limbs. Place a sturdy Great Helm on his head, this was a popular bucket-shaped helmet worn by knights for over 200 years.

This vicious weapon was designed to swing around behind the opponent's shield to inflict terrible injuries.

STEP 6

Give him a shield for further protection and create a dramatic design or emblem to go on the front of it. Finally draw the war flail (sometimes called a morning star) in more detail.

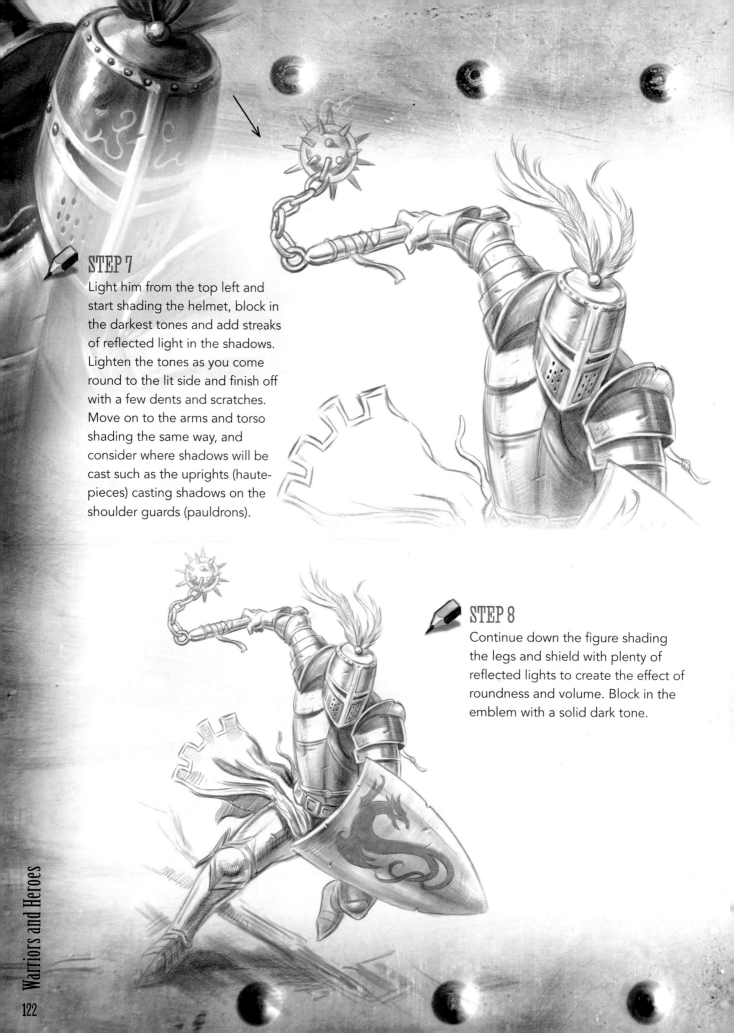

STEP 7

Light him from the top left and start shading the helmet, block in the darkest tones and add streaks of reflected light in the shadows. Lighten the tones as you come round to the lit side and finish off with a few dents and scratches. Move on to the arms and torso shading the same way, and consider where shadows will be cast such as the uprights (haute-pieces) casting shadows on the shoulder guards (pauldrons).

STEP 8

Continue down the figure shading the legs and shield with plenty of reflected lights to create the effect of roundness and volume. Block in the emblem with a solid dark tone.

Medieval Knight

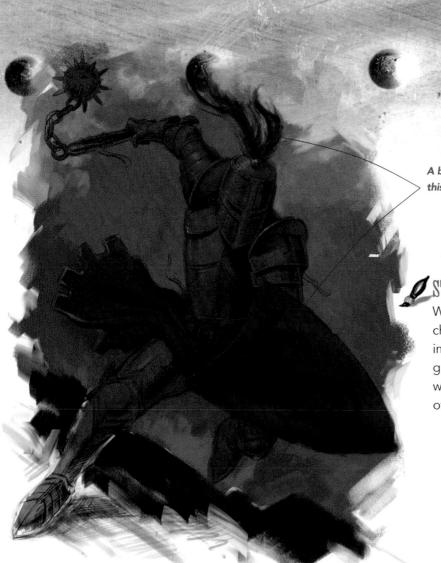

A blazing, blood-red shield and plume make this warrior stand out on the battle field.

STEP 9

Wash in a first pass of colour, choosing fiery reds and oranges to imply a fierce battle is raging. The greyish metal colour of the armour will take on the warm yellow tinge of the background.

STEP 10

In a second pass of colour, add light and dark washes to the figure to bring out the roundness of the forms. Then loosely indicate a castle under siege in the background, and paint in some flames to add to the drama.

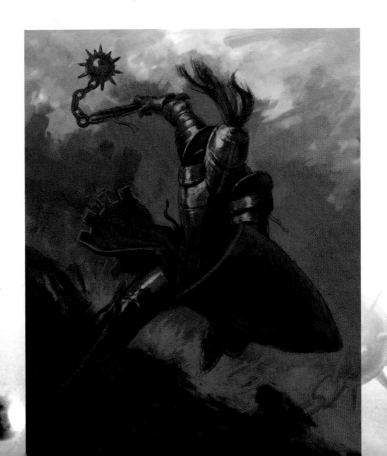

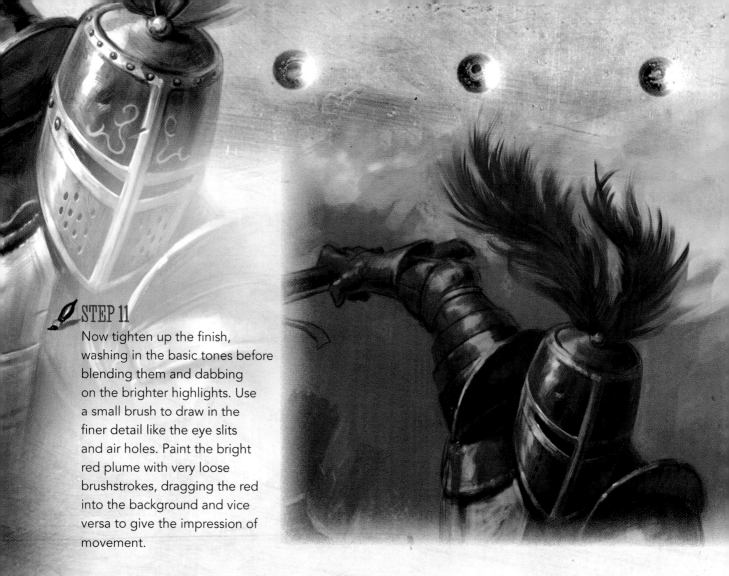

STEP 11

Now tighten up the finish, washing in the basic tones before blending them and dabbing on the brighter highlights. Use a small brush to draw in the finer detail like the eye slits and air holes. Paint the bright red plume with very loose brushstrokes, dragging the red into the background and vice versa to give the impression of movement.

STEP 12

Move on to the breastplate, blocking in and modelling the large shapes first, then finishing with details and bright highlights.

Artist's tip

However badly a piece is going, fight it to the bitter end or you will not improve. Surrender is not an option!

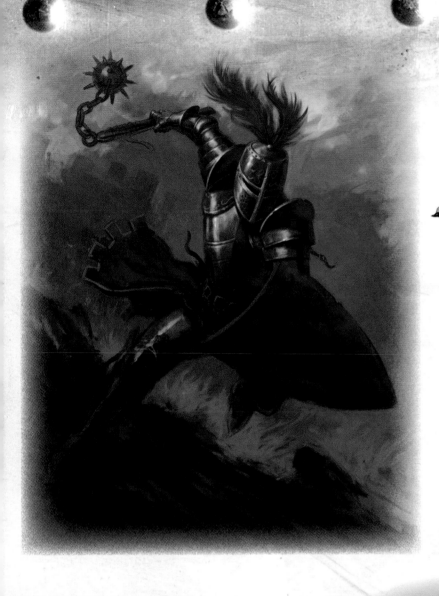

STEP 13

As you paint the plates on the arms, keep in mind their direction, shape and perspective. Make the highlights bright and add plenty of warm reflections in the shadows.

STEP 14

The flail is a fiddly job. Paint and model the ball shape first before drawing on the spikes with a detail brush. Using the same brush, carefully outline each link of the chain with a dark colour and block in the middle tones finishing with highlights.

STEP 15

Tidy up the cloth around his waist and try to convey movement with a loose handling. Begin the shield by redrawing the outline and then start laying in the red tones. Ignore the emblem at this point – you need to shade and model the desired shape of the shield first before superimposing the emblem on top.

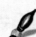

STEP 16 – FINAL IMAGE

Paint the legs the same way as the rest of the figure, blocking in the tones, modelling the forms and then drawing on the finer details. On the near leg, paint lots of red reflections cast by the flames behind and fade the colours of the far leg to give the impression of distance. Lastly, add some flaming arrows in the sky to add to the medieval mayhem and the knight is finished, literally dressed to kill!

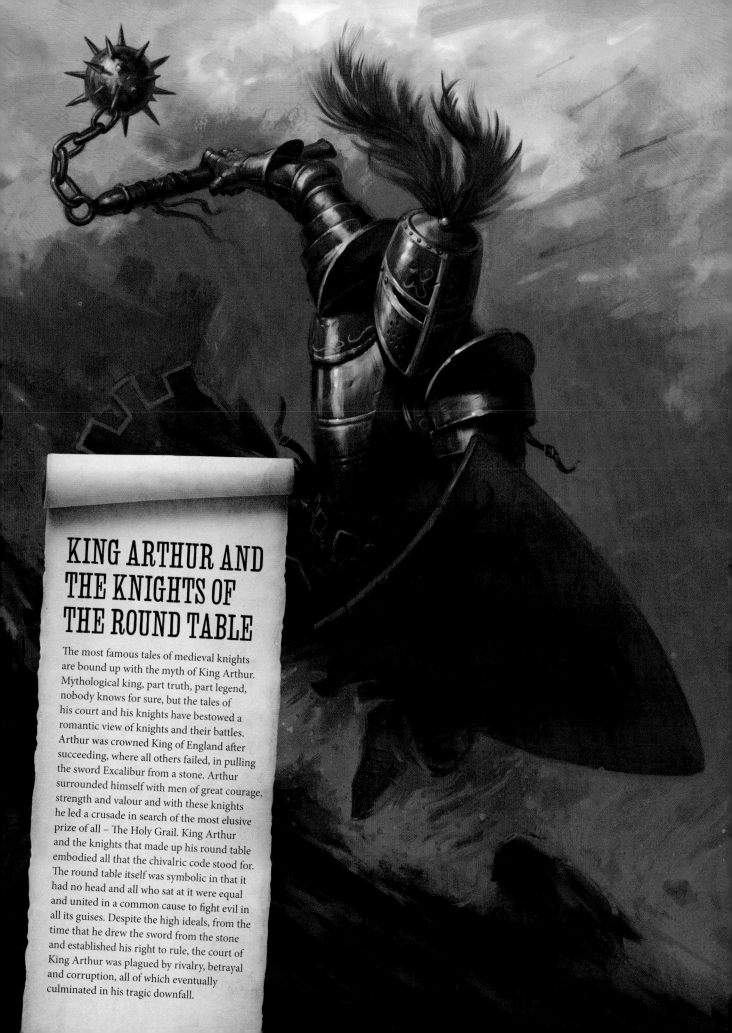

KING ARTHUR AND THE KNIGHTS OF THE ROUND TABLE

The most famous tales of medieval knights are bound up with the myth of King Arthur. Mythological king, part truth, part legend, nobody knows for sure, but the tales of his court and his knights have bestowed a romantic view of knights and their battles. Arthur was crowned King of England after succeeding, where all others failed, in pulling the sword Excalibur from a stone. Arthur surrounded himself with men of great courage, strength and valour and with these knights he led a crusade in search of the most elusive prize of all – The Holy Grail. King Arthur and the knights that made up his round table embodied all that the chivalric code stood for. The round table itself was symbolic in that it had no head and all who sat at it were equal and united in a common cause to fight evil in all its guises. Despite the high ideals, from the time that he drew the sword from the stone and established his right to rule, the court of King Arthur was plagued by rivalry, betrayal and corruption, all of which eventually culminated in his tragic downfall.

BIOGRAPHICAL NOTE

Alan Lathwell is a London based freelance illustrator who specialises in fantasy art. His interest in art started at an early age and was fed by the dark and ancient myths of Celtic and Norse mythology. His work has been used to illustrate books, role-playing games, collectable cards, CD covers, comics and magazines. For more information and further examples of Alan's work, visit…
www.alanlathwell.deviantart.com
alanlathwell.cgsociety.org

ACKNOWLEDGMENTS

A special thanks to Scott Purdy and Freya Dangerfield for lighting the spark for this book, and to the team at D&C for making it a reality.

Index